PENGUIN BOOKS

The Goodness of Dogs

India Knight is the author of four novels and five previous non-fiction books: *In Your Prime*, the bestselling diet book *Neris and India's Idiot-Proof Diet*, the accompanying bestselling cookbook *Neris and India's Idiot-Proof Diet Cookbook*, *The Thrift Book* and *The Shops*. India is a columnist for the *Sunday Times* and lives in Suffolk with her family and dogs.

D0968861

By the same author

FICTION

Mutton

Comfort and Joy

Don't You Want Me?

My Life on a Plate

NON-FICTION

In Your Prime

The Thrift Book

Neris and India's Idiot-Proof Diet (*with Neris Thomas*)

Neris and India's Idiot-Proof Diet Cookbook

(*with Bee Rawlinson and Neris Thomas*)

The Shops

The Goodness of Dogs

INDIA KNIGHT

Illustrated by Sally Muir

PENGUIN BOOKS

PENGUIN BOOKS

UK | USA | Canada | Ireland | Australia
India | New Zealand | South Africa

Penguin Books is part of the Penguin Random House group of companies
whose addresses can be found at global.penguinrandomhouse.com.

First published by Fig Tree 2016
Published in Penguin Books 2017

001

Grateful acknowledgement is made to the authors, their Estates and publishers for permission to
quote from the following: *Dog Songs* by Mary Oliver (Penguin, 2012), copyright © Mary Oliver,
2012; 'Shackleton's Decision' by Faith Shearin (*Moving the Piano*, Stephen F. Austin State University
Press, 2011); 'For a Good Dog' by Ogden Nash (*Candy is Dandy: The Best of Ogden Nash*,
Carlton Publishing, 1994); 'Obituary for His Dog Daisy' by E. B. White (*E. B. White on Dogs*,
Tilbury House, 2013); 'The 10 Commandments from a Dog's Point of View', copyright © Stan
Rawlinson, 1993; 'A Dog Has Died' by Pablo Neruda, translated by Alfred Yankauer ('Un perro
ha muerto', *Jardin de invierno*, copyright © Pablo Neruda, 1974 y Fundación Pablo Neruda).

The moral right of the author and of the illustrator has been asserted

Typeset in Garamond MT Std by Jouve (UK), Milton Keynes
Printed in Great Britain by Clays Ltd, St Ives plc

A CIP catalogue record for this book is available from the British Library

ISBN: 978-0-241-97549-7

www.greenpenguin.co.uk

For Brodie, for when he can read

'Because of the dog's joyfulness, our own is increased. It is no small gift. It is not the least reason why we should honor as well as love the dog of our own life, and the dog down the street, and all the dogs not yet born. What would the world be like without music or rivers or the green and tender grass? What would this world be like without dogs?'

from Mary Oliver, *Dog Songs*

CONTENTS

INTRODUCTION: A BREED APART 1

1. SHOULD YOU GET A DOG? 13

2. WHAT DOG? 29

3. PREPARING FOR THE PUPPY 75

4. GETTING THE PUPPY HOME 95

5. FEEDING ALL DOGS (NOT JUST PUPPIES) 109

6. THIS CHARMING DOG 131

7. DOGS AND THE WORKING PERSON 173

8. GROOMING AND PRETTINESS
(AND HANDSOMENESS) 201

9. DOG FASHION 221

10. THE ADOLESCENT DOG AND BEYOND 235

11. MIDDLE AGE AND BEYOND 245

12. DOGS IN HEAVEN 259

APPENDIX: A FEW GOOD DOG THINGS
TO SEE YOU ON YOUR WAY 267

INDEX 275

ACKNOWLEDGEMENTS 285

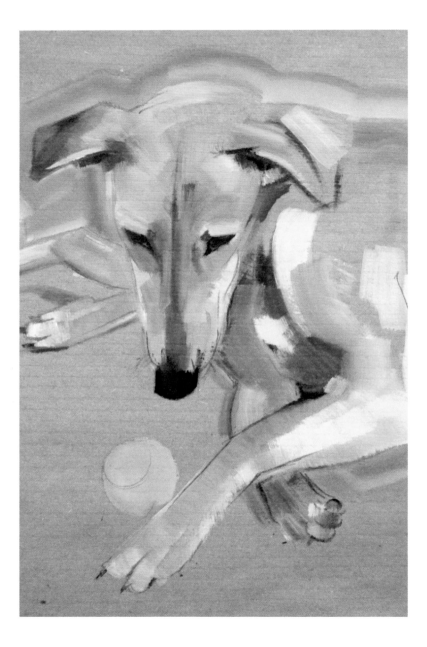

Introduction

A BREED APART

If you love dogs – the idea of dogs, the reality of dogs, the imaginary dog you will have one day, the beloved dog you had as a child or the dog(s) you already own – then this book is for you. This book *loves* you, because this book believes that dog people are just kind of . . . not better, exactly, but a breed apart, let's say. A special pod. Chosen. (I totally mean 'better' – I'm just trying to be tactful.) This is because we are privileged enough to *know* dogs, to have them in our lives and to experience first-hand the joy – the great and infinite heart-soaring joy – that they bring.

I am demented about our dog, Brodie.* I am crazed with love for him. He is my favourite person-that-isn't-actually-

* Indeed, without wishing to be sexist, it is in Brodie's honour that I have referred to dogs as 'he' throughout.

a-person. It's like a joke, how much I love him. I think about him all the time. On the rare instances where I'm away from him, I pine and look at photographs of him on my phone, as if I were twelve and he were dog-Zoella, except it's so much more special than that. I feel such *tenderness* for him. He moves me deeply.

I was not always in the special pod. I liked dogs well enough as a child – my dad, with whom we did not live, always had them. There was a chipper dachshund called Felix, whom I think I probably only remember from photographs, and a fairly simple-minded Dalmatian called Sophie, who used to chase me round and round the dining table when I visited.

My father found the chasing hilarious. Later he had a girlfriend called Christine who had two Dobermanns,

whom I used to take for walks. I don't think these Dobermanns were very nice – my blurry memory remembers that this Christine, who was, improbably, a very rich horse vet (it doesn't sound quite right, does it? I don't think I'm remembering that bit properly), lived in isolated splendour in the middle of nowhere, with security alarms and electric fences everywhere and these two canine guards, who, as my father cheerily pointed out, were trained to kill (maybe she was in fact an arms dealer, I'm thinking). Anyway, I liked going on walks with them because they were so incredibly obedient. I was quite a young child at this stage – seven or eight – and, well, imagine anyone sending a child off for walks with trained-to-kill Dobermanns now. My father had great faith in the goodness of dogs, though perhaps in a different sense to mine.

I got my first dog, Otis, sort of by accident. I had two little boys and a very new boyfriend, and I'd vaguely wondered – aloud – whether it mightn't be nice to have a dog. The boys, of course, started jumping up and down at the idea and saying, 'Please, please can we have a dog? Pleeeeeease.' We bought a dog breeds book and got as far as identifying a likely breed, and then one day this boyfriend appeared with a puppy. Just like that. It turned out his dad bred this very breed, the divine Soft-Coated Wheaten terrier, and there we suddenly were, with a dog.

Called, following a hastily convened Saturday morning family conference in my bed, Otis.

Now, this is a bad thing to say in my Introduction, but I didn't really *love* Otis. I was very, very fond of him, but mostly he got on my nerves. I was a single mother, nominally at least, of two very boisterous little boys; I didn't have a huge amount of money, I had even less time and I was working constantly. I was permanently knackered. I longed for sleep – that kind of sleep where you dream, almost erotically, about sleep and lie-ins. My little boys loved Otis, but they were little boys: they also loved Spiderman and Bionicles and football. Otis had pressing needs of his own, quite aside from being walked, stroked, trained and fed: dogs just do, and it's absolutely fair enough – it is a dog's right. But I hadn't really understood this, and as the years went by I became more and more aware that I wasn't really meeting Otis's needs. I'd walk him for about an hour a day: he really needed double that, at least. He was only trained in the most basic sense – he was a very nice dog – but it must have been annoying for him to never have his considerable intelligence challenged. He was the least important person in the house, because he wasn't a person, he was a dog. And I think he suffered for it. I certainly suffer to remember it.

Don't get me wrong: he had everything a dog could want, except the occasional undivided attention of

someone who really, purely loved him and was wholly focused on him. By the time I'd worked all of this out, I was a knot of Otis-guilt, plus I had a new baby who took up all my time and attention. It makes me so sad to think of it now. Good old Otis, so loving and forgiving and noble, and so permanently in the way. In the end he went to live with my children's grandmother, in the countryside, where he *was* properly loved and very happy (something else to bear in mind: he developed serious health problems as a result of having been bred from a problematically small gene pool – but I'll get back to this in Chapter Two).

I was not a bad owner to Otis, and in the later years I delegated the love. I just believed, as my then-boyfriend believed, and as people have believed for decades on end, that dogs were – well, just dogs. More demanding than cats, but mostly there for your amusement and convenience: the least important member of the family. We believed – and people still believe this – that it was perfectly normal to leave dogs alone for periods of time; that dogs who chewed your stuff up while they were left alone were being 'naughty'; that dogs were pack animals who had to 'be taught' that you, the owner, was the 'alpha'. If a dog weed in the hallway, we'd say things like, 'I swear he does it on purpose,' as if the fault were the dog's rather than our abject failure to take him for a walk

in time, or a manifestation of anxiety or stress on the dog's part.

We belonged to the generation – generations, plural – that thought that a dog who'd fouled a corner of the sitting room 'needed' to 'have his nose rubbed in it', 'to be taught a lesson', and it didn't occur to us that this was both disgusting and unkind (well, actually, it did – it's not a thing I've ever done, thank God). We didn't think that it might be absolutely baffling for the dog, for reasons I'll explain later, or that that bafflement might turn itself into various unhappy behaviours and anxieties. That sort of approach was very much the norm. It amazes and saddens me that, in some quarters, it still is: only the other day I was talking to a friend about her mother's dog, who was visiting. This dog peed everywhere. 'Poor dog,' I said. The Otis-era me would have said, 'Ugh, what a nightmare.' When the friend said the thing about rubbing the dog's nose in the pee, I felt genuinely incensed and upset on the dog's behalf; I was so cross that I actually made my excuses and left.

But we didn't know back then that any of this was already old-fashioned thinking, and that people who raised happy dogs no longer did any of these things and instead based their training methods on kindness and rewards. We were stuck with a parent- or even grandparent-inherited Barbara Woodhouse type of thinking about dogs. We

never lifted a finger to Otis, obviously, but we knew people who 'disciplined' their dogs, just as we knew people who smacked their children. It wasn't our cup of tea, but we were perhaps in the minority, dog-wise. In fact, we thought we were really evolved. We never hit our dog, we fed him what we thought was the best food for him, we never put him in kennels ... we thought we were great owners. And, in our limited way, we were. But we could have been so much better.

Fast-forward a decade or so, and my new partner and I (I, mostly, which is ironic because I'm not the one who walks into a room and bellows, 'WHERE IS THE BEST DOG IN THE WORLD? WHERE IS THE KING OF PUPS?') started wanting a dog again. The children were now young men, and their sister, who'd come along in the intervening period, was nearly ten – not a needy, demanding toddler or a human-dynamo five-year-old, crucially. My partner's children were a couple of years older and very keen on the idea too. Everybody slept through the night those days; we had a bit more money; I worked from home; and at the time we lived in London next to two big parks ... So we started doing our research again, gingerly. I wanted another Wheaten – they are such *lovely* dogs, both inside and out, and, being super-sociable, brilliant with big families. We talked to various breeders, identified one, sat back and waited ...

and on 1 April 2013, a litter was born. We went to visit it, in Sheffield, a few weeks later. We both knew which puppy was 'ours' within seconds – it really was love at first sight. That love, pretty powerful in the first place, has now, three years later, reached, as I was saying, almost demented levels. It grows and grows.

Of course, I could detour here about child substitutes, but I'll leave it until Chapter Nine. I am repulsed by the idea of 'fur babies' – a phrase that sets my teeth on edge: aside from the fact that dogs are dogs, anthropo-morphizing and infantilizing animals to this extent is really unhelpful to everybody, not least the poor dog-baby (I mean, which is it? Stick him in a bonnet, why don't you?). Having said that, our dog was – and remains – very much *ours*: he is a physical, living consequence of our relationship. We love each other, and him. We also love our five children (and they him: my eldest son is twenty-three and when he comes home, after saying hello to whoever's around, he says, 'Where's Brodie?'). No, what has changed since the days of Otis is the way in which people think about dogs. It seems to me to be quite a seismic change. If you can remember the 1970s, you'll remember things like the fact that dogs were always milling about on their own; sometimes you'd see them meeting up with their dog mates and hanging out in dog posses. You'd 'let the dog out' and he would

wander about for a bit and come back. Dogs really did steal sausages from butcher's shops (and almost every high street really did have a butcher). They were mostly fed scraps from the table, rather than luxury dog food with artisanal ingredients (they mostly lived longer too). They were robust. They were dogs. This isn't a nostalgic lament – they also got run over all the time and, as I was saying, people didn't necessarily treat them with the greatest kindness.

But there's been this huge dog-change in the intervening decades, and I think it's left us confused about some things. Dogs have become humanized, if you will – not in the 'my baby' sense but in what we have learned about canine behaviour and psychology. We know so much more than we used to about what dogs are really *like*. One example (many more will follow): that whole pack animal/showing him who's alpha thing. So yes, dogs are descended from wolves. But wolves, it now turns out, operate as cooperatives. The alpha, where he exists – he isn't a given – organizes the troops to ensure that everyone has the help they need. Far from leaving the poor delta and epsilon wolves out in the cold, the pack helps them to achieve success. It's a collective effort.

They all help each other, with the alpha taking the lead. The alpha isn't, therefore, some mean-ass macho brute who wishes to leave the lesser wolves broken and cowering, but rather a kind, intelligent creature who makes sure no one's left behind. He's not the bad boy, snarling and eating all the steak, but more kind of like a wolf special needs coordinator. Compare this with the idea that we need to 'teach our dogs who's boss' and you start seeing how old-fashioned that kind of thinking seems. (The other – heartbreaking – thing we now know is that dogs are so desperate to please their beloved owners that they would rather be mistreated and hurt than ignored. This is why those harsh training methods work – because of the good and loving character of the dog, even if the dog is frightened and has no clue what's going on. It's got nothing to do with the effectiveness of the method.)

As well as celebrating the goodness of dogs, I want to unravel all of this stuff in this book. Should you get a dog? It's a really serious commitment. And if you were to get a dog, how would you go about it? What breed should you pick? Pedigree or mutt? What should you feed him, how should you train him? And if you already have a dog, or dogs, how can you make your existing dog or dogs happier? There are dozens of questions to be answered. I don't seek to answer them as anything other than a lay person who happens to be crazed with

dog-love. If you want books by academics, vets and animal behaviourists, you'll find a useful list at the back of this book. I've read those books, and they're great, but they can be quite dry and boffiny.

Think of the book you're holding as a friendly manual, or a repository of useful dog facts. It's a book – both compendium and memoir – about how to be a happy person who owns a happy dog. I really like people. I just also really like dogs.

Because the salient fact is this: dogs are made of joy. They are happiness with four legs and a tail, and when they're happy it isn't just the tail that wags, but the whole bottom half of the body. It's fantastically endearing and completely life-enhancing. Proximity to happy dogs makes your life a thousand times better (and proximity to sad dogs is no good for man nor beast). Onward, then, to dog nirvana, or as close as any of us are likely to get. And three joyous yaps for the goodness of dogs.

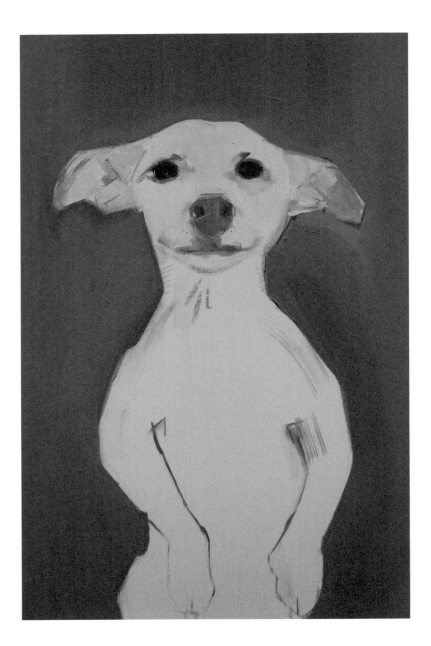

SHOULD YOU GET A DOG?

The short, from the heart, answer is 'Well, yes, obviously. Dogs are life.' But that kind of approach to dog ownership can end very sadly, with neither dog nor humans having an especially nice time. This is because not everyone knows what to expect when they think about getting a dog, beyond 'Dogs! Yay!' I bought every dog book going when we decided to get Brodie, and I still felt unprepared for what it was actually like once he arrived. Many of those books assume a degree of calm, level-headed competence that isn't necessarily a given for everyone. They also assume that you have oodles of time to devote to your new puppy. This is a good assumption, and it is quite right to emphasize the vital importance of spending time with the new puppy. But most people don't have that much time spare. Most people feel there aren't enough minutes

in the day as it is. So here's some bluntly put, important stuff to bear in mind when you're deciding whether to go for it or not.

Dogs have immutable needs. They don't potter off and do their own thing. They are not particularly adaptable. They need your help. They hate being alone (and if you think there exist breeds of dogs to whom this doesn't apply – sorry to disappoint, but you're wrong. All dogs love company and *hate* being left). You can't go away for the weekend and get a neighbour to come in and feed them. They don't use a litter tray: when they gotta go, they gotta go. They are seriously energetic. And new puppies . . . new puppies are *exhausting*.

I'm not shaking my head and chortling fondly about them being lovable little blighters here. I am remembering the slight shock of puppyhood and am giving you a serious, clear-eyed warning. If you can't do the time, don't get a puppy. Never underestimate the hard work you'll have to put in, or you'll end up like a friend of mine who tearfully and reluctantly took her puppy back to the breeder because neither she nor her young family could handle the constant effort and stress involved in looking after him. By the way, this is the kindest thing you can possibly do if you realize belatedly that you've made a mistake. Reputable breeders will understand. But she and her children were broken-hearted at having to take

back this most longed-for creature. Moral of the story: it's better to inform yourself properly in the first place. Don't get distracted by pretty leads and collars and super-comfy baskets and how nice it'll be when you're gambolling photogenically across a meadow with your puppy. Don't let your desire for a dog blind you to any of the realities of ownership. It's not fair on anyone, and that includes you.

As I was saying, the phrase 'fur baby' makes me want to gag, but there's some truth in it at this initial stage. Puppies *are* babies. They're babies who have been taken away from their mum and siblings to come and live with you. They're little and anxious and phenomenally needy. Initially, they have no idea what's going on. You can't reason with them, or tell them to wait a second, or to delay the imminent wee because you're just scrambling these eggs.

And you can't, I don't think, ignore any of these facts, or somehow breezily crash through them, if you want a happy dog. You really do have to devote time and effort to the situation and to the dear puppy. You know how no one *really* tells you how utterly exhausting childbirth and the weeks immediately after can be? Obviously I'm not comparing getting a puppy to popping out a nine-pound baby using only the miracle of cervico-vaginal infrastructure, but the aftermath – the 'So now this creature lives in our house and, OH MY GOD, WHAT HAVE WE DONE?' aspect – is not dissimilar. Also, babies wear nappies. Dogs don't. I know someone who thinks there is such a thing as post-puppy depression, in which this small yapster runs wildly amok and you contemplate the enormity of what you've done with feelings of rising panic and regret.

Puppies require constant care and attention. After they've acclimatized to their new environment, they're insanely and gratifyingly excited to be there. They race about (in their tiny way). They chase everything – do be aware of this, as your toddler, young child or dog-averse visitors may not like it at all: puppies have needle-sharp teeth and a pronounced and insatiable taste for eye-level ankles and shoes. You can't train a teething puppy to not want to bite interesting, satisfying moving targets, so you're stuck with the nipping for a

while, though you can discourage it up to a point (see page 99).

They pee everywhere. They poo everywhere. They want you to cuddle them, and to play with them, and they really don't care that you're trying to get children ready for school, or trying to work, or trying to make supper, or indeed trying to sleep (or have sex, and see page 79). Of course, all of this is unbelievably cute, and it comes with big fat square paws, jaunty tails, boingy ears and adorable faces. The weeing and pooing isn't so bad if you have hard floors and can keep the puppy in an easily cleanable area – but be aware that even then you are 100 per cent guaranteed to stumble across surprise turds and puddles. Your upholstery will suffer, not just from lav-style incidents but from the aforementioned chewing, as will table legs. Any item left on the floor will be fair game: in the puppy's delighted eyes, it will be a thrilling toy, chew, snack or all three. Our tiny little puppy destroyed two pairs of my best and most expensive shoes – they weren't even shoes, actually, but supposedly robust boots. He gnawed the heel off one and the zip off another. Think also handbags, satchels, school shoes, parcels, books, old newspapers, wires and cables such as laptop chargers, jumbo packs of loo roll, shopping that's waiting to be unpacked because you're mopping up a wee, etc., etc. Unless you're the kind of super-organized

person who never leaves anything on the floor, damage will occur. When you introduce the puppy to other rooms – I'll get to this later in the book, but it's a good idea for your dog to meet the world in manageable chunks, I think, rather than being allowed to roam/poo/chew all over your flat or house – those other rooms will present unbelievably exciting new opportunities for more chewing/crapping/frenzied roaming.

Now, some people don't mind any of this, because they simply don't. It's just an aspect of character, a personality thing. They're not squeamish about picking up shites, they mop wees up absent-mindedly with the edge of their sleeve, and if a puppy decides to eat a cushion, they're really not that fussed. I hate to generalize, but there's a big house v. small, town v. country element to all this: if your floor is tiled and you're used to mud, and if you can open the door to the garden and let the puppy do most of his exploring out there, you will have a much easier time. Puppies aren't allowed out unless carried until they've had all their vaccinations at twelve weeks (you get them at eight weeks, so that's a month indoors), but obviously if you have direct access to a private, sole-use garden (in which the puppy can't meet any diseases), then that's going to significantly simplify your puppy life. Equally, if you live in a small flat with no outdoor space,

you're going to have to be super-vigilant when it comes to safeguarding your furnishings and possessions.

There's also an age component. If you're older, or recently retired, or if your children have left home, or if you are lavishly independently wealthy with no need for a job, then the time element of puppy-raising will probably bother you less. It may not bother you at all, in fact: you may find it heart-warming and lovely to be bringing up this little animal. He may give you a whole new lease of life. You may wish to devote all your waking hours exclusively to him and to invite him to sleep on your bed. That's a perfect scenario really. And it's in contrast to how you may feel if you're a stressed-out mother of four who doesn't have time to change the sheets or get her roots done, let alone mop up after a crazed little ball of furry energy.

The other very important thing is that, as the ad goes, once you have a dog, you have him for life. The puppy stage passes by in a flash: you have a good ten to thirteen years (more, hopefully) beyond that. Older dogs don't need the same level of constant attention as puppies, of course, and things get lovely, easy and comfortable once they're trained. But you still can't scoot off for an impromptu weekend away, you still have to walk them properly twice a day, regardless of what the weather's doing, you still have to groom them and bathe them and mentally stimulate them and care for them. You have to

love them, even when they've stopped being adorable and are old and tired and sick and maybe a bit stinky. If your ducks are in a row – if you want a dog, are prepared to put in the work in order to make both that dog's life and your own life happy and contented – then of course caring for an old dog will be a pleasure and a privilege. We want to avoid a situation where that isn't the case. And so, to recap, ask yourself these questions. Dogs end up in shelters because people get them on the spur of the moment, without thinking things through.

- 🐾 **Why do you actually want a dog?** 'Because the children keep nagging me for a puppy' is not a good enough answer. Puppyhood is demanding, and then it passes. Dogs live for up to fifteen years. Getting a dog is a really serious commitment for *at least* the next decade. It is not one you should make lightly. Also, puppies: it's a given that they are delightful. But how do you feel about looking after an ailing, sick dog that's on his last legs?
- 🐾 **Do you have enough time?** All dogs, even small ones, need daily exercise throughout their lifetime. Some dogs – larger breeds, on the whole, though it's slightly more complicated than that (see page 65) – need *a lot* of exercise.

Equally, all dogs need mental stimulation: it's not like, having exercised them, you can just ignore them. In addition, as I was saying, a brand-new puppy is a lot like a brand-new baby. You also need time, and plenty of it, in which to train and socialize your dog, either by yourself or by going to puppy classes/dog school (see page 155). Do you have enough spare time in your day? Dogs are not loners. They need company.

How much space do you have? Dogs, unlike cats, do not leap gracefully out of the way when you're trying to make dinner; nor do they stash themselves away helpfully on top of the fridge. Dogs may go and lie on their bed and keep a watchful eye on things from there, but they may equally find your cooking profoundly interesting and stimulating, and prefer to keep an eye on it/you from right up close. They love being under your feet, because they love your feet. If you have a small kitchen, this might be a problem. Do you have a big sofa? If you're going to allow your dog on to furniture (see page 79), he'll want to watch telly with you – half on you, possibly. If you're going to allow the dog on to your bed (highly contentious, see page 79), then the bigger the dog, the bigger

the bed needs to be. Now, this isn't to suggest that everybody who wants a biggish dog needs an enormous house with giant sofas and rows of super-king beds, but you do need to take physical space into account. Obviously, it's not wise to get a big dog if you live in a tiny flat. Picking the correct breed is of the utmost importance, and doubly so if space is limited. Some small dogs can be far more energetic and noisier (annoying for neighbours) than some larger, more relaxed breeds. Pick a breed that's right for your living arrangements.

Let me interrupt myself here to point something out: I do realize that at this juncture I am the Voice of Doom, and that this may all sound discouraging. But there is nothing sadder than going through all of the excitement of getting a dog only to find that the reality of ownership is at complete odds with the expectations you had about what it would be like. So bear with me. There's a right dog for everyone. What I am doing here is helping you to find the right dog for you. Everyone deserves their Prince Dog Charming.

🐾 **Do you have green space nearby that you can access relatively easily?** Your garden doesn't count, unless it runs to several acres. Depriving a dog of green space to run in is an act

of cruelty. I know lots of urban dogs get walked round the block, but that doesn't mean they wouldn't rather be running, running, running, wooooo-hooooo, through beautiful springy grass.

🐾 **Do you have enough money?** Dogs aren't crazily expensive to run, but they're not free either. A pedigree puppy will cost you around £800, though obviously mongrels are cheaper and rescues are cheaper still: prices vary according to the charity, but at the time of writing, rehoming a dog from the Dogs Trust, for example, costs £120. Nevertheless, I would say that everyone needs to take out pet insurance, because vets' bills for the simplest things run into the hundreds of pounds, and anything more serious – requiring anaesthetic, say – can very quickly run into the thousands. Not having pet insurance can be ruinous, but pet insurance isn't cheap in the first place. Then factor in dog food, toys, accessories such as collars and leads, bedding, occasional trips to the groomer's, flea and worming tablets, and so on . . . it does add up. If your household is out at work or school all day, you will also need a dog walker if you want your dog to be sane/happy/ unstressed (for why, see Chapter Seven). And if

you want a well-trained dog but don't have the time or confidence to do it yourself, there's the cost of dog school.

🐾 **How patient are you?** Everybody wants a lovely, happy, healthy, friendly dog. I expect all dogs want to be lovely, happy, healthy and friendly too. I feel that dogs are all born this way, possessed of these excellent attributes, but it's not quite enough: they need to learn how to be *your* dog, in *your* family and *your* home. The good news is, they want to learn all of those things. Dogs are tremendous pleasers. But it requires a lot of involvement from you, regardless of whether you feel like a couple of hours of dog-involvement after a full day at work or not.

🐾 **Do you have existing children?** As I've said, I was not able to look after our dog 100 per cent properly when the children were babies or very small – but that's a completely subjective viewpoint, and your mileage may vary: maybe I was just a bit pathetic. For what it's worth, I personally wouldn't get a *first* dog if I had really teeny children. I'd get a second or third dog, no problem, because I'd know what I was letting myself in for. Needless to say, having a well-trained dog is absolutely essential if you have

young children. A frustrated, anxious or unhappy dog does not go with children *at all*; it can be life-changingly dangerous.

🐾 **What about future children?** Don't get a dog if you're due to give birth in two months. Seriously. Just trust me on this (aside from the deranged insanity of it, the dog, who is busy bonding himself to you for all eternity, may not necessarily take kindly to the new baby).

🐾 **Do you travel a lot?** Are you wedded to the idea of holidays abroad? Sure, pets can get passports – but travelling in the hold isn't especially nice for them. If you're the kind of person or people who whizz about visiting friends or relatives every weekend, would your dog be welcome? What would you do if he wasn't?

🐾 **Have you thought about backup?** Who will look after the dog if you are unexpectedly called away?

Having tried to give you all the negatives so that you know what to expect, here's an incontestable positive: dogs are absolutely brilliant. There's nothing I, or anyone, could write that would persuade me otherwise. They are worth the time, the money, the effort, the trudging bleakly through violent gales and more. They're

worth the scooping up of diarrhoea in public places (or, on one joyous occasion, tapeworm – yards of it, a few days after we'd moved to Suffolk, in the local market town, on busy market day, *with no poo sack on me because I'd left my jacket in the car.* I was this close to sitting on the pavement, next to the tapeworm, and crying, but then a kind man appeared with a spare poo bag).

Dogs are fantastic life-enhancers if you're alone, and just as wonderful if you're a family. They're the best possible addition to childhoods, middle age and old age. They gladden the heart. They make you a better person. There's an incredibly naff motivational saying that I keep coming across online: Be the person your dog thinks you are. Naff as it is, it makes me feel tearful, because it's so true. Your dog thinks you are literally the best, most wonderful, kindest, loveliest person that's ever lived. And you thank your lucky stars every day for being the owner of the world's best dog.

If, having read this chapter, you feel you're not quite ready for one, put this book on a shelf and revisit it when you are (provided that you're mobile, you're never too old for a dog). And give yourself a gold star, because thinking, 'Actually, now's not the right time,' isn't a cop-out but an intelligent, informed and compassionate act. Dogs live long lives. Acquiring one is not something you should do on a whim. Nobody wants to fast-forward a little and find that they are the horrible person who slightly wishes the dog wasn't there.

If, on the other hand, you're going, 'Yes! Yes! I want a dog! I want a dog right now! I am ready! I am completely undeterred, even by the tapeworm!', then read on. The next bit matters a lot, because the breed you pick is of *vital* importance. You also need to decide whether you want a puppy or an older, already-trained dog; a pedigree or a mutt; or indeed a rescue dog.

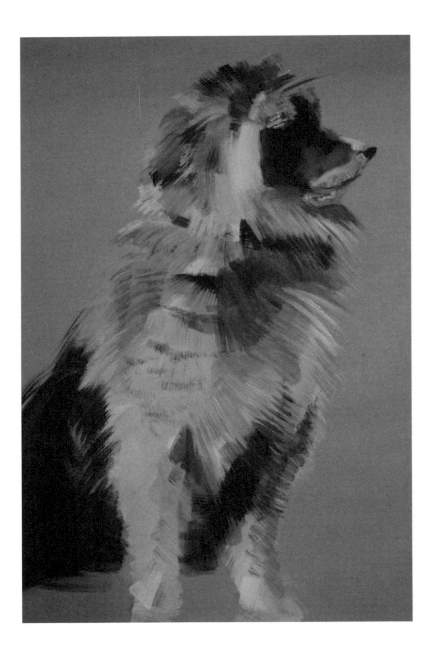

Chapter Two

WHAT DOG?

Dogs used to be – well, dogs. Just dogs. Doggy dogs from Dogsville. Part of the problem with the way in which we have increasingly humanized dogs over the past couple of decades is that it has eroded their honest, straightforward status as *dogs*. They are now often a strange sort of hybrid – not quite a child, because obviously that would be mad, but not quite just a dog either. They are Dog Plus, or perhaps Person Minus. We attribute human emotions and behaviour to them – guilt, shame, sulking, jealousy, naughtiness – and are convinced we're right. We dress them up in coats and jerseys. We find them the best beds money can buy; in fact owners of some particular breeds make a virtue of accessorizing (I'm broadly against this. Just setting out my stall at the start). We feed them with care; we think long and hard when selecting leads and collars and water

bowls and blankets, in a way that would have astonished our dog-owning grandparents or great-grandparents. These days, outside of the context of working dogs, we think of dogs as smaller, furrier versions of us. And nowhere is this more evident than when we choose one.

Dogs used to appear without much forethought. A person, or a family, would decide to get a dog and then one of two things would happen: either the dad would appear with a dog one day or everyone would go off to the pet shop. These days, buying a dog from a pet shop is pretty much always a disastrous idea (see page 37 for more on this) and dads don't wander off into the foggy night to go and see a man about a dog any more. We think harder – a great deal harder – about what kind of dog we'd like. This is good. And we usually base our choice on looks alone. This is quite a lot less good.

Basing your choice on looks is hot-wired into our DNA as humans: some faces are just more appealing to us than others, and that is simply fact, and that fact applies to all creatures, including dogs. Each of us has our prejudices: I, for instance, don't like dogs who seem to have extreme difficulty breathing, and I don't find bulging eyes cute, but I accept that lots of people do, and that's cool (it isn't especially cool for the dog, see page 34). I personally prefer a medium or large dog to a tiny one, but I can completely see why some people feel exactly the opposite

way. The good thing is that there are more than enough breeds – and cross-breeds and mongrels – to go round, to satisfy every taste, to make every dog and his owner happy with each other. The thing to remember is that, with dogs as with humans, the looks part is only a small part of the bigger picture. *Do not pick your new dog on looks alone.* Here's why.

Many dog breeds have existed for hundreds, if not thousands, of years. Those dogs' basic characteristics are bred deep in their bones. A working-strain retrieving breed needs to retrieve, just as much as he needs food and water; a herding breed needs to herd, ditto. In the absence of any sheep, some herding dogs will still herd anything he can – you, strangers, your small children, the old lady down the road who totters about on her Zimmer. We used to live near a woman who had four rescue huskies. There are an awful lot of huskies – and other huge wolf-looking dogs – in rescue centres because people can't look after them: they get them on the grounds of the breed's great physical beauty and then come a massive cropper. Huskies are very fast and very powerful – they were bred to pull heavy sledges at speed across the Siberian plains, as well as to hunt – and don't take well to suburban gardens and dainty half-hour walks. Anyway, this woman had adopted four. It was kindly meant, but ultimately selfish. I would see her heading towards

the park most days. On the way there, they'd be all tangled up in their leads – they are huge and very strong dogs who happen to need painstaking training on the lead. She could barely control them. They'd snarl at any other dog or passer-by. The woman, who was clearly stressed out, would angrily shriek, 'Cross the road! Cross the road!' at anyone who happened to be walking towards her. We lived in the middle of London at the time, where the pavements are busy and full of people going about their business. Everyone crossing the road when ordered to do so by a random woman with dogs struck me as impractical: clearly at some point it wasn't going to happen, and chaos would ensue.

And then, when she did get to the park, the dogs went absolutely bonkers with the sheer giddiness of being free to run off the wretched lead, and she couldn't get them to come back to her. Additional issue: huskies, if they have not been trained since puppyhood, sometimes see smaller creatures as prey.

It was super-nice of her to have rescued these dogs, but they should clearly have been in the countryside, running for hours somewhere good and flat, like Norfolk, with an owner who was as energetic and physical as they were, not with a well-intentioned, city-dwelling woman of a certain age living in a flat. I mean, huskies helped the US Army's Search and Rescue Unit during

the Second World War. They're not Snoopy. This isn't to
say that they can't ever make good pets; they can. They're
friendly and beautiful, and provided that you can
give them a shit-load of exercise and firm training, you'll
be fine. But you need to know that before you get one,
or before you think your longed-for dog is 'bad' or
'naughty' or 'difficult' for just being himself – for doing
what he's been bred to do for hundreds and hundreds of
years.

Or take vizslas. Stunningly beautiful dogs, currently
highly fashionable to boot. They are lovely companions:
intensely loyal and devoted, gentle, affectionate. They're
also hunting dogs – they're gun dogs, originally bred to
hunt rabbit, duck, wolf and boar, among others. They
have sackfuls of energy and, being very bright, they need
to be well trained and well exercised in order to feel
happy, at which point they become lovely, loyal compan-
ions. But you cannot take a vizsla and just sort of bumble
about town with him, leaving him home alone while you
go to work and giving him a quick trot round the block
when you get back. And yet you'd be surprised at how
many people do. And then they ring up a dog trainer and
say, 'I've got an incredibly naughty, badly behaved dog
and you're my last hope,' not realizing that the dog is
just . . . being the type of dog its breed has been for hun-
dreds of years. It's like buying a sausage and then standing

around complaining that you want this sausage to be more like lemon drizzle cake, and that something is wrong with the bad sausage for not complying. Inform yourself first.

So what breed is right for you? It's not quite as simple as I've made out above. While it is true that all breeds have particular needs, it is also true that some quite unlikely breeds do, given time, effort and the full beam of your attention, make excellent family pets. And anyway, you might not care about breeds. You might just want a dog you simply hit it off with.

The question of pedigree dogs is a vexed one. Take Crufts. The 2016 German shepherd judged to be best in his category seemed, to a lot of people, to have something terribly the matter with him. He had an oddly sloping back and spindly legs, and there seemed to be something wrong with the way he walked. As well as the public, the presenter of the show, various vets and the RSPCA said they were 'shocked' and 'appalled' by the dog's appearance – unlike the judges, who gave him a prize. His owner said the dog had a clean bill of health. This is one example out of hundreds of extremely unpleasant and distressing stories about dog breeding, in which irresponsible breeders seek to produce dogs whose appearance is more and more extreme in order to satisfy customers' misguided notions of exemplary breed standards. So bear that in mind, and by extension the fact that some breeders

who appear to have very, very desirable dogs — champions and award-winners that are the absolute incarnation of their breed — may care more about 'perfect' appearance than about producing happy, well-rounded dogs. For what it's worth, I would prefer to buy a puppy from an amateur breeder — a nice lady with a garden, who just really likes this or that breed and wants to sell to people who are looking for a lovely pet — than from a super-posh one who is really only interested in producing dogs that can be 'shown' professionally, and in catering to people whose ambition it is to own such a dog. Breeder-wise, I'd always aim for the roast chicken dinner, as it were, over the foie gras, and what I mean by that is the uncommon, rare-bird breeder who breeds her dogs for *personality* as well as looks — which is to say, who tries her hardest to breed *pets* rather than professional beauty queens. This is a very good reason for visiting the breeder at home. Brodie's breeder, a lovely woman called Zoe Thomas, who lives in Sheffield, had this to say when I asked her why she breeds Wheaten terriers: 'For me it is partly to fund my own pack of three ageing Wheatens and their two offspring — soon to be added to with the next generation — and my daughter's vet degree. It's also fun breeding, rearing and pairing the puppies off with new families/owners. It can be sad and frustrating, but thankfully not too often if you interview the new families

properly. You gain many friends to walk with if the puppies end up nearby. Those that move far away can be followed on Twitter!'

The desire for fashionable pedigree dogs is behind puppy farming – an innocuous name for a horrendous practice. Some puppy farms are legal, incredibly. A puppy farmer is, according to the Kennel Club, defined as:

a high-volume breeder who breeds puppies with little or no regard for the health and welfare of the puppies or their parents. A puppy farmer's main intent is profit. As a result they typically separate puppies from their mothers too early (eight weeks is generally recommended), ignore guidelines about the maximum frequency of litters (the Kennel Club will not normally register more than four litters from any one bitch because of concerns that the current legal limit of six litters per bitch can be potentially detrimental to a dog's welfare), provide inadequate socialization of puppies, sell puppies through third parties i.e. away from the environment in which they are raised, keep puppies in poor husbandry conditions and fail to follow breed-specific health schemes or to apply basic, routine health measures such as immunization and worming. As a result, the puppies bred by puppy farmers are

more likely to suffer from common, preventable, infectious diseases, painful or chronic inherited conditions, behavioural issues and shorter life spans.

In addition to the sheer cruelty of all this, and the sub-par puppies they produce, puppy farms are usually filthy. Dogs can be kept inside, with no access to fresh air, twenty-four hours a day, in cramped, dirty quarters. According to the charities that seek to highlight the abuses of puppy farming, the dogs sometimes live out their existence in complete darkness. They eat, sleep and give birth in the area where they also wee and poo – something that a dog will never do if he can possibly help it. They are neglected, matted, ill, psychologically disturbed and will be riddled with behavioural problems if they ever get rescued. When a bitch is too old or knackered for yet another litter, she is killed. It is absolutely *hideous*. Puppy farms sell their stock to pet shops and via ads on the internet, on places like Gumtree. They are supposedly inspected once a year by the council, which will issue a licence based on the premises rather than its prisoners' well-being. That's the 'legal' ones, of course. There are illegal ones too. You can imagine what they must be like (actually, you probably can't. I've seen footage. It was worse and more nightmarish than I'd anticipated, and I'd anticipated an awful lot).

All of this is simply horrible – it's battery farming by any other name, and like battery farming it turns my stomach. So that, in a nutshell, is why you should never buy a dog from a pet shop or from an online ad. Purchasing these dogs keeps the 'farms' going. You should always buy a dog from a breeder *that you have personally visited*, unless of course you choose to adopt a rescue dog. Let's look at that first.

Rehoming a Dog from a Charity

There are thousands upon thousands of dogs in the UK that need rehoming. There are so many that eventually some of them have to be put down, to make room for the constant influx of new ones. It is terrible. Some of these dogs have been rescued from abuse, some are there because their owners died, some because they were found wandering about and their owners were untraceable (always get your dog chipped – it's now a legal requirement – and don't forget to let your microchip company know when you move house). Some have been deliberately abandoned – there must be a special place in hell for people who deliberately leave their dog on the motorway, which, incredibly, is still a thing. Some have been given away, some are there because

people have moved house, some are strays and some are simply there because their owners realized that they couldn't cope with a dog despite thinking that they could, or that the Great Dane/studio flat scenario wasn't so clever after all. So from the outset you see that there are all *sorts* of rescue dogs. Obviously a terrified, traumatized dog who's had a horrible life of abuse for years is not the same as a deeply loved little lapdog who belonged to an old lady who died. A frightened, anxious dog who can't look anyone in the eye is not the same as a healthy dog who until recently had a very jolly time. A traumatized dog will not immediately make a good family pet; a dog who's run wild will need especially firm training; and so on. Charities can only do so much in helping unhappy dogs with behavioural problems to adjust to love and kindness. It is up to you to continue their work at home.

Dog rehoming charities such as the Dogs Trust* will tell you everything they can about a particular dog – where he's come from, why he's there, and the kind of people they think he would be happiest with. Note that most rescue centres aren't keen on you rehoming one of their dogs if you are expecting a baby – the dog needs

* There's a list of these charities in the Appendix.

time to acclimatize to his new home and of course new babies turn everything upside down.

You must listen to the rehoming charity's advice before you start making your mental selection (besides, they won't let you adopt a dog if they think you're not right for each other, which means the likelihood of you adopting a dog who turns out to be mad and/or danger-ous is close to zero). This is especially important if you have young children who have not had a dog before, or who are only familiar with dogs who have known them all their lives. My daughter, for instance, sometimes uses Brodie as a pillow, or opens his jaws wide to express admiration at his super-sharp, super-white teeth (which are to do with what he eats, or rather doesn't eat, see page 118). She knows not to do either of these things with any other dog she ever meets, but then she's grown up around dogs and is twelve years old. I wouldn't be so sure of her

ability to stick to her word if she were six. You don't want six-year-olds inspecting the super-sharp teeth of a dog they've known for two days, no matter how sweet-tempered and family-friendly that dog appears to be.

Equally, rehoming a dog is rather like adopting a child. It's slightly more complicated than giving him a bed and a meal and expecting him to crack on and be happy. Rescue centres tend not to want their dogs to go to people who are likely to leave the dog alone all day – and really, if you're going to leave your pet at home alone all day, maybe don't get a dog. Dogs are highly social, and indeed sociable, animals, which means they need a social life with you. A lot of 'badly behaved' dogs are only 'badly behaved' because they're abandoned for the larger part of the day – but I'll get to all of that in the chapter about dog behaviour. What I want to say here is that it is wholly unreasonable to pick up a dog – rescue or otherwise – on a Sunday and go to work as normal on the Monday.

Having got that out of the way, a rescue dog who's matched to you or your family is a wonderful, win-win thing. There is an excellent argument to be made for people only ever acquiring dogs from rescue centres. Incidentally, rescue dogs come wormed, flea-ed, micro-chipped, vaccinated and neutered/spayed.

MICROCHIPPING

This is now a legal requirement. If your dog is not micro-chipped, you are liable to a £500 (at the time of writing) fine. The microchip in question is about the size of a grain of rice. It is inserted between the shoulder blades and causes the dog zero discomfort. The chip contains information such as who the dog's owners are, where they live and how to contact them. It also contains information about the dog's breeder, if he has one. Dogs being traceable to their breeder reduces the problem with puppy farms (see page 37). Microchipping also deters dog thieves, means local authorities can get lost dogs home quickly, means vets can contact you immediately if there's been an accident and means that action can be taken against the owners of dogs who are found in a bad or neglected state. Your vet can microchip your dog. The Dogs Trust offers a free service if you can't afford vets' fees – chipmydog.org.uk lists locations of where this service is available. To update your contact details if you move house, contact your relevant UK microchip database. They are:

- Anibase 01904 487600
- Pet Identity UK 0800 975 1960

- Petlog 01296 336 579
- Pet Protect 0800 077 8558
- PETtrac 0800 652 9977
- SmartTrace 08445 420 999

Pedigree Dogs

There is also quite a good argument for buying, or more usually rescuing, mutts over pedigree dogs. Nobody's mucked about with them, other than Nature herself, and this usually means that they are robust and capable, as opposed to your more highly strung, Princess-and-the-Pea dogs. They don't have to conform to exacting breed standards – these are kind of mad, and solemnly list what is and isn't 'acceptable' in such-and-such a breed, from colour and shape to length of tail and distance between the ears. Only dogs that tick every box on the list are judged to be 'right'. I personally find this deeply creepy, and I can't think of anyone who'd care less if their beloved dog's tail didn't meet the breed standard, unless they wanted to show those dogs professionally, something I also feel deeply ambivalent about. Sitting on a table at the NEC in Birmingham with your hair all bouffed out doesn't seem to me to be a

glorious evolution from noble wolfdom, or indeed, in the case of bouffy Pekingese, from your stately descent from royal dogs at the Chinese imperial court. There is an indignity to it that I find hard to surmount. Also, I've probably watched *Best in Show** one too many times.

The fact remains that when we think of dogs, we tend to think of specific breeds. Helpfully, these breeds all have their particular characteristics. I suggest you buy a breed guide if you're after minute detail – or look up your breed's official UK club for super-specific info – but otherwise this is the basic gist. Please note that all pure-bred dogs are more at risk of inherited, breed-specific illnesses and genetic conditions than random, scruffy mutts.

* *Best in Show* is an American spoof documentary from 2000, written and directed by the great Christopher Guest (remember *This Is Spinal Tap*). It follows five dogs and their owners who are competing in a dog show. It is hysterically funny and I could not recommend it more highly.

🐾 **Primitive dogs** These, it
is thought, have not spent
the past few hundred
years being bred for
particular characteristics,
and are therefore closer
to their wolf ancestors than
other breeds. They're a bit
like dingoes, except they
come inside and sleep on the bed.
No, I know that doesn't sound especially
reassuring. It's not supposed to. Dogs in this
category include both Mexican and Peruvian
hairless dogs. The best known of them is the
basenji, who yodels instead of barking, but even
basenjis are few and far between. They have
lovely soulful faces, though. My guess is you
haven't bought this book because you're
thinking of getting a primitive dog.

🐾 **Working dogs** This is a large group, bred, as
the name implies, to help with various jobs,
usually pastoral, like herding or guarding sheep
or cattle. They tend to be very physically strong
and hardy, and very clever and quick to learn.
They can make lovely pets. Examples include
lots of magnificent giant Belgian shepherd or

cattle dogs for whom I have
a soft spot, like the
Tervueren, the
Groenendael and the
Bouvier des Flandres;
the German shepherd,
the schnauzer, the
Border collie, the corgi

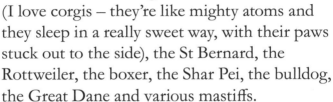

(I love corgis – they're like mighty atoms and
they sleep in a really sweet way, with their paws
stuck out to the side), the St Bernard, the
Rottweiler, the boxer, the Shar Pei, the bulldog,
the Great Dane and various mastiffs.

- **Spitz-type dogs** These are wolfy-looking dogs,
like huskies or malamutes. Dogs in this
category that weren't bred to pull sledges were
also bred for hunting, racing and herding
(reindeer). They're
adapted to freezing
climes and have
double coats that are
hard work to comb.
As ever, they can
make fine pets if
you're willing to put in
a considerable amount

of training and exercise. Smaller dogs within this category include Pomeranians (scaled down through breeding since the nineteenth century: they used to be much bigger. Speaking of scale, I only discovered recently that prehistoric horses, from which our domestic horses are descended, used to be tiny).

🐾 **Sight hounds** This means dogs bred for hunting through the goodness of their brilliant eyesight. They are also *slight* hounds (I'm here all week), in that they are slim, elegant and muscular, with narrow heads and long skinny limbs. Aesthetically, there's something of the aristocratic consumptive about them to me – a whiff of the chaise longue – but I mean that as a great compliment. They run like the clappers, obviously, so that analogy doesn't go very far. Lovely family dogs, but some people advocate only walking them on a lead, which is a bummer since they love to run (this isn't remotely a sight-hound rule, just an observation. Plenty

of them run about like crazy). The problem is
that once a sight hound spots his prey, he may
well keep running until he catches it, with little
regard for the fact that you're standing there
calling him back until you're puce in the face.
This group includes greyhounds, whippets and
Irish wolfhounds – divinely handsome, divinely
tempered dogs, in my limited experience, if
you're not put off by the fact that they're easily
six feet tall when standing on their hind legs.
Greyhounds and whippets are a more
manageable size.

🐾 **Scent hounds** Noses, innit, and also bred
for hunting. Those specifically bred for
hunting foxes in packs don't make particularly
good pets, unsurprisingly, not least
because they're keen to follow scent trails to
their bitter end. But that still
leaves breeds like
dachshunds (very clever,
make good guard dogs,
can be snappy), basset
hounds, beagles
(best with older
children) and
Dobermanns.

🐾 **Terriers** I can't write an entire book about dogs and pretend to be completely objective. To me, terriers are the kings (and queens) of dogs. I love their characters — no-nonsense, brave, tenacious, jaunty, energetic, chipper, clever, charming — and I love the way they look, with their strong square jaws and sturdy bodies. Terriers are packed tight with goodness. They were originally hunting dogs, but hunting dogs for normal people rather than the well-to-do. The smaller ones were used for hunting below ground and the longer-legged ones for hunting above it. In time, some of them were crossed with bulldogs for the purposes of dogfighting and bull-baiting, now obviously both illegal. Those fighting breeds remain in existence and have a bad rep, but they can make lovely pets. Note that all terriers are incredibly single-minded and are therefore not necessarily a cinch to train — though, frankly, no dog is a cinch. They love to dig and aren't automatically brilliant with other dogs, unless you introduce

them very young, in which case they're usually fine. Breeds include Yorkshire terriers (originally bred to catch mice and rats in Northern mine shafts and woollen mills: not obvious when you see them trot about with ribbons on their heads); Norfolk and Norwich terriers (be still my heart); Parson Russells, Jack Russells, Airedales, Irish terriers (swoon), Soft-Coated Wheaten terriers (like Brodie, triple swoon), Patterdale terriers, bull terriers and Staffordshire bull terriers – these last two, as I was saying, initially bred for fighting. As I was also saying, don't let that put you off. Staffies, for instance, are heroically brave, kind, loyal dogs who are lovely with children *provided they are well trained* – a caveat that extends to all breeds.

Gun dogs Before there were guns, there were dogs trained to find and catch game, as we have seen. Once guns came along, different sorts of dogs were needed. Gun dogs break down into three categories:

- Pointers and setters, who cleverly locate prey. Pointers literally freeze, as though they were playing statues, when they've found their prey (like Dug, the extremely nice dog in Pixar's *Up*). Setters do the same thing, but they crouch (or 'set') when they pick up the scent.
- Spaniels, who flush game from wherever it's hiding.
- Retrievers, who collect game and bring it back to the hunter. They have soft mouths so as not to damage the game they're carrying. Retrievers are good swimmers because they were originally bred to retrieve waterfowl. I saw six of them swimming in the sea at St Ives one summer: they were further out than the people and they were a truly splendid sight.

Some gun-dog breeds can do all three things – locating, flushing and retrieving. These include Weimaraners and vizslas. As well as anything with pointer, setter, spaniel or retriever (e.g. Labrador retriever) in the name, the gun-dog group also includes standard poodles, who were originally bred as water dogs.

🐾 **Companion dogs** Well, so called. Any dog can be a companion, and in my view all dogs *are*

companions. But this group was bred deliberately for the purpose, I suppose because rich ladies in silk dresses didn't necessarily want giant Irish wolfhounds or slavering mastiffs perched on their dainty knees, being idly fed crumbs of macaroon. Some of these dogs are scaled-down versions of larger working breeds; lots originate from the imperial courts of China. This is the group that's been most – well, either 'chronically fiddled about with' or 'selectively bred', depending on your point of view – to appeal to our human eye. It includes various bulldogs, the pug, the bichon frise, the Pekingese, the shih-tzu, the Maltese, the poodle (as opposed to the bigger standard poodle), the Cavalier King Charles spaniel, the King Charles spaniel, the chihuahua and the Dalmatian, who is clearly not a lapdog and interestingly was actually used in the UK in the nineteenth century as a 'carriage dog', running alongside horse-drawn carriages to protect the horses.

In the US, Dalmatians would run alongside fire engines and bark to tell people to get out of the way. But then nobody needed carriage dogs any more and now they're bred purely as companions. Note: Dalmatians shed like crazy.

Cross-breeds These include random crosses that just happened by accident, deliberately cross-bred dogs with slightly silly names, like Maltipoos or Puggles, and older cross-breeds that have been around for hundreds of years, like lovely lurchers. If you would like a fashionable designer cross-breed, remember to study the breed characteristics and exercise needs of both halves of the dog – so, for a Cockerpoo, look at the traits of the cocker spaniel *and* the poodle. Bear in mind that your Cockerpoo may not be like your friend's Cockerpoo: one half of the mix may be more dominant in one dog than in another. These deliberate cross-breeds *tend* to have very nice characters – which have

literally been bred into them – but this isn't an infallible, 100 per cent guarantee.

It may interest you to know that the 'inventor' of the Labradoodle, one Wally Conron, has publicly lamented his own creation. Back in the 1980s, he wasn't a professional breeder – he was working as the puppy-breeding manager at the Royal Guide Dog Association of Australia. He met a couple from Hawaii. The woman had vision problems and her husband was allergic, but they still really wanted a dog. What could they get that would work for their particular circumstances? Conron's solution was to cross a Labrador retriever with a standard poodle, and thus the Labradoodle was born. It worked beautifully: the dog was gorgeous and didn't trigger the husband's allergies. But Conron now believes that he unwittingly set off a chain of events that was bad for dogkind. 'I've done a lot of damage. I've created a lot of problems,' he told the Press Association in 2014. The issue was that soon everyone wanted a 'designer dog' Labradoodle, and the 'horrific' puppy farms kicked into action. Their dogs, as we have seen, often have severe

health problems. 'Instead of breeding out the problems, they're breeding them in,' Conron said. 'For every perfect one, you're going to find a lot of crazy ones.' He said he'd created 'Frankenstein' and was filled with regrets. When Barack Obama expressed a wish for a Labradoodle for his family, Conron wrote to him strongly urging him to check his pedigree. (The president eventually went for a Portuguese water dog.) Mr Conron stopped breeding Labradoodles twenty years ago.

I agree with Conron. By all means have a comedically named designer dog, but for heaven's sake check where he's come from. Even aside from the horrors of puppy farming, two breeds means two sets of genetic predispositions to certain conditions and diseases. Check, double-check and then triple-check again. A reputable breeder will gladly share all of this information with you.

Breeders

The best way of finding a breeder is by word of mouth. Failing that, the Kennel Club keeps a list of nationwide breed-specific breeders (this is not by any means a cast-iron guarantee of excellence, but it's a good place to start). Ring

the breeder up and have a chat; see if you like the sound of each other. A good breeder will ask you questions: Is this your first dog or have you had lots before? Where do you live? Will someone be at home with the puppy? Is there a park nearby if you don't have a garden? Are you aware of the cost and energy involved? How familiar are you with the breed you've chosen? And so on. If that all goes well, arrange a visit. If the breeder is local, they may want to visit you too. It's not a bad idea to ask what problems are associated with the breed during this initial phone call – nicely, obviously, rather than aggressively. A good breeder will say, for example, 'Hip dysplasia, but both the parents and the grandparents have been screened, and it hasn't been an issue for any of the dogs I've bred so far,' etc., etc. They will not say, 'None.' Ask when the puppies will be ready to leave with their new owners: the absolute earliest is seven weeks; eight is the norm and some breeders prefer to wait until twelve weeks.

All good breeders should be happy to leave you in peace to look at the litter – that means all of the puppies, hanging out in a pod with their mother, rather than individual puppies on their own (which can mean they've cruelly been removed from their mother and that their provenance may be very iffy). The puppies are far too small for kennels and should be indoors in a comfortable basket or similar in a clean, warm, friendly room. Inspect the mother: what

she is like will give you a good idea of what her offspring will be like, though bear in mind that she is with her new puppies and will be defensive of them. The dad, aka the sire, will probably be somewhere else altogether, but if you'd like to meet him as well, do say (bearing in mind that the answer may be 'He's 400 miles away').

The puppies should not seem cowed or frightened, though obviously puppies are perfectly capable of shyness. They should look chubby, shiny and in good health. Some will be perkier than others, as with people. I'd go for the perky-looking ones, but some people prefer a shy-pants, and that's fine too – just make sure that the shy-pants isn't shy because he's poorly. The breeder should be able to show you a vet's reference and that the litter is registered with a breed association. Do ask what the puppies will be weaned on, and whether the breeder has views about what they should eat when they're older.

Ask to see where they will play outdoors when they're a bit bigger.

Questions to Ask the Breeder

🐾 **Are your dogs screened for inherited diseases? Could I see the certificates?** The only answer to both these questions is yes.

🐾 **Can you provide me with references from previous buyers?** Bits of paper don't really cut it – ask for phone numbers.

🐾 **Have you registered the puppy with a kennel club?** The answer should be yes.

🐾 **Can you provide pedigree documentation for the puppy?** Again, the answer should absolutely be yes.

🐾 **How long have you been breeding this breed and what do you specifically like about it?** You're hoping for a look of transported delight and a long list of why these dogs are simply the best breed that ever existed. If the breeder also enthuses about the particularly wonderful *character* and temperament of the litter's mother or father, that's even better.

🐾 **Will the puppy be well socialized by the time we come and take him home? How will that happen? Will you take him into the outside world yourself?** A puppy doesn't necessarily have to be waltzed around town to become socialized – hard to do anyway before he is fully vaccinated – but exposure to other dogs and pets, as well as to as wide a variety of people as possible, including children, is a good thing because it builds confidence. Equally, it helps if the puppy is used to being handled.

🐾 **Will the puppy be fully wormed and vaccinated when we come to collect him?** Puppies are vaccinated at six–nine weeks and then again at ten–twelve weeks. They are fully protected two weeks after the second vaccination. Obviously if you're picking up your puppy at eight weeks that means four weeks indoors once you get him home (I don't think enough people realize this. It can be quite tortuous, see page 100).

🐾 **Will the puppy be fully weaned?** This happens at seven weeks – if the breeder says no, it means she's selling them too young.

🐾 **What should I feed him when I get him home? Will you give me a diet sheet?** The answer should be yes: the puppy will need to keep eating what he's been fed for a few days before you introduce – should you wish to – a new diet.

🐾 **How old is the mother?** She should be over one, and not clearly knackered and ancient.

🐾 **How many litters has she had?** It is illegal to breed a bitch more than six times in her lifetime.

A Warning

If you're in the market for *two* puppies, it is not usually considered a good idea to get them from the same litter. Siblings who are homed by the same family can focus entirely on each other, rather than on their humans. This doesn't always happen, but when it does they make their own little sibling world, to the exclusion of all others, like those Silent Twins years ago. This means that they are not good at bonding closely with people, preferring to bond closely with each other; are slow to learn to read human signals; are slow to trust people; and are slow to learn toilet-training. They become disproportionately upset if they are separated even for a few minutes. They

can fight pretty horribly with each other when they reach adolescence. As I say, it isn't a dead cert that all of these things will happen, but there is equally no guarantee that they won't.

Teeny-Tiny Dogs

When a friend heard I was writing this book, she narrowed her eyes meaningfully and said, 'I know how you feel about small dogs. Just remember, *small dogs have their own thing going on.*' And she was absolutely right. I used to have a dreadful prejudice, but have come to realize that small dogs *do* have their own thing going on. Small dogs are, in their own way, marvellous beasts.

Consider:

- Small dogs are versatile and portable in a way that bigger dogs simply aren't. You need a whole

separate hatchback-style compartment to transport
the latter; the former just hunker right down on the
back seat, and whoosh, you're off. Easy as pie.
Going to a dog-friendly restaurant? Bring your
small dog and watch how he hardly takes up any
space and doesn't get in the way. Going down an
escalator? Pick your small dog up and carry him.
I'd literally break my back trying to carry Brodie,
plus we would look absurd.

• Small dogs don't USUALLY need as much
exercise, by simple virtue of having small legs
(though it very much depends on breed). Mind you,
this cuts both ways: if you're never happier than
when rambling for days, a small dog may not be
the sensible choice for you, though you could
always put him in your backpack with his head
sticking out. But if you're short of time, a city
dweller, not especially near any parks and generally
keener on a more low-maintenance hound,
outdoors-wise, then the small dog fits the bill –
though I repeat and repeat loudly, absolutely not *all*
small dogs. A terrier, for instance, would not be the
right choice.

 Note that this is not to say small dogs don't
need *any* exercise – just less. They can still have
considerable racing-about needs. Nor does it mean

that running up and down the stairs will do
(actually, running up and down the stairs may not
be very good for them – it depends on the breed,
and see page 67, but it's to do with hips). Equally,
small dogs aren't easier to train or more biddable or
malleable; if anything, they're super-determined.
They're still 100 per cent dog, just smaller.

- Some small dogs are really sturdy. These are my
 favourite small dogs.
- Small dogs can have – and often do have –
 absolutely gigantic characters. Sometimes they have
 far more character than a relatively placid bigger
 dog, who can seem really quite simple-minded by
 comparison. They charge about in a determined
 way and are never shy of asserting themselves.
 Some people say that this is Napoleon/short-man
 syndrome, but I don't think so – I think small dogs
 just don't realize that they're small. If you're after
 dog lolz, small dogs and their quirks can be deeply
 comical. Even I have been known to crack a wintry
 smile at small-dog antics.
- The idea that ALL small dogs are bred to be
 decorative companion dogs is incorrect. Many of
 the most popular small dogs, notably the terrier
 breeds (my personal favourites out of all the dogs,
 have I said?), were originally bred as working farm

dogs, often as ratters. As not all small dogs are lapdogs, it would be a mistake to treat them as such. An awful lot of them are right little toughies – 'farm-strong', as Cameron says (of himself) in *Modern Family*. Many small breeds are also extremely clever.

- Speaking of which, I don't think it's true that small dogs are gay. Not that there's anything wrong with gay dogs, *obviously*. But I know several gay people who eschew the small dog in the mistaken belief that small dogs confer effeminacy on their owners. Maybe a chihuahua isn't terribly butch, but it's really a question of interpretation, and of styling it out. Chihuahuas – likenesses of which have been found on Mexican artefacts dating back to AD 100 – have a long and noble history and, believe it or not, guard their owners fiercely and devotedly (making them unsuitable dogs for families with very young children, by the way).

- Having said all of that, I am still not crazy about teeny-tiny yappy dogs. This is chiefly because they're so fricking noisy, in a way that, were one being unhelpfully anthropomorphic, could be read as being incredibly needy and constantly going, 'I'm here! Look at me! Hey, everybody! Here I am! Here I still am! Hello! Hiya! Yap! Yap! YAPYAP.'

Mind you, I can see that some people would find this endearing. By and large, though, the smaller dogs do seem to make the biggest noise. On the other hand, yappy dogs are often made that way by their yappy owners, who have no respect for their dog's dignity.

- It all boils down to whether you like mini things – whether you find them pleasing and attractive or spooky and undergrown. One of my sisters positively loves anything mini, the smaller and more microscopic the better. She thinks small things are extra-sweet. I see that this is true about babies, but not so much about anything else.

Other Things to Think About

Temperament and looks – in that order, I would strongly suggest – are the most important things, but there are other factors you will want to look at. They are all to do with manageability. Think about:

🐾 **Exercise** It isn't just a question of dogs needing to walk in order to stretch their legs and nip to the lav. Dogs need to run, to play, to sniff, to chase, to track, to bound, to leap, to mark their territory,

to meet other dogs. Unless your dog is really extremely old or infirm, exercise will be what he most enjoys about his day. You must bear this in mind. Don't just think that a small, short-legged dog won't need much more than a trot round the block: some of them are incredibly energetic. Equally, some huge breeds are so huge that too much exercise is bad for them and their spindly bones. Inform yourself about your breed's specific requirements. If your dog isn't exercised enough, he will be bored. If he is bored, he will whine and play up. He may become destructive. He will be a pain to be around and, more to the point, he will be unhappy. Seriously: do your exercise homework. And if you already have a whiny, destructive dog, ask yourself whether he runs about enough. The answer is probably a big fat no (see page 192).

🐾 **Mental stimulation** Clever dogs need clever owners. They need to be mentally occupied, otherwise they get bored or anxious and, as above, start acting up and/or being destructive. This is especially true of dogs who were bred for doing jobs outdoors and who now are effectively unemployed in a domestic setting. It's fine, but you need to give them things to do. It's not hard:

hide a treat in a hard-to-open toy, play with your dog, talk to him, teach him tricks that make him mentally agile. This all takes time. I'm not going to give you a list of clever dogs v. stupid dogs. No dogs are stupid. All need mental as well as physical stimulation; but some need more than others. Incidentally, a dog trainer once told me that dogs also need mental stimulation when you're out walking with them. 'My dog is always learning as well as walking,' she said. Don't just absent-mindedly walk your dog – try to make a point of using the walks as training opportunities every now and then.

Where you live Aside from the glaringly obvious – your studio flat isn't suited to an enormous Italian Spinone – there are other considerations. A tall, thin house that's full of stairs might be hard work for a short-legged dog that's genetically prone to hip problems. A dog that is crazy about digging isn't going to pause to consider your parquet flooring or expensive carpet.

How you live Dogs make a mess, at least initially. They just do. It's all very well living in a city near a wonderful park, but clearly your dog is going to come back from his rainy winter walks absolutely filthy and muddy. Where will you dry and clean

him? Are you proposing to carry him upstairs to give him a shower if he's rolled in fox poo? Could you use the kitchen sink or do you consider that unhygienic? And if you're going to carry this dog around when he's dirty because you don't have an outdoor tap, is the breed you have in mind easily portable even as an adult?

🐾 **Who is actually going to look after this dog, every day, for well over a decade?** This is a boring, unromantic question that is nevertheless central to the success of the whole enterprise. Don't delude yourself into thinking that 'the children will walk him' or 'everyone will take turns'. The children may fall wildly in love with the dog. It doesn't necessarily follow that a sixteen-year-old boy will take the dog out for a good long romp on Saturday afternoons when he could be hanging out doing God knows what with his friends. Equally, a five-year-old child may consider the dog her best friend and ally in the entire universe, but she isn't going to walk him either, because she's five. Beware here also of the old-fashioned 'round the block for a wee' approach to dogs, which is ingrained in middle-aged people who had a dog as a child. 'We never walked our dog for an hour in the rain when I was little,' this

person will say, as though you are making wildly unrealistic and possibly unhinged demands. 'He went off by himself. Until he was run over in his prime. Yeah, OK, I sort of take your point, but still.' If you, the person who is holding this book, really want a dog, accept that you will ultimately be responsible for that dog's happiness.

🐾 **Shedding** Most dogs shed and moult. Technically, they shed their summer coat in the autumn, in preparation for a denser winter coat, and then they shed said thick winter coat in the spring, ready for a lighter summer coat. There's a massive amount of hair involved, but still – at least you know what to expect, and when. The problem is that our domesticated dogs often shed all year round. This is basically because they're not in the wild: central heating and electric light confuse their neurotransmitters, with the result that an awful lot of them shed twelve months a year (rather like town birds singing by street light at 2 a.m.). And so you end up with dog hair everywhere – not just on the rug or on the sofa, but all over your clothes, and it's a real bastard to get rid of completely. Now, there are things you can do, which I'll get to in the chapter about feeding. But there isn't a magic solution – dogs just *shed* – unless you go for a breed

that is either non-shedding or very low-shedding. These breeds are given in the list that follows. If the shedding thing is of utmost importance to you, the Kennel Club recommends, as would I, that you contact the relevant breed club for more information. Please note that if your concern is medical rather than domestic, even non-shedding breeds can trigger asthma attacks and allergies.

- Bedlington Terrier (these terriers have lamb-like faces)
- Bichon Frise
- Bolognese
- Bouvier des Flandres
- Chinese Crested
- Coton de Tuléar (who sounds like an especially languid Oxbridge contestant on *University Challenge*: 'Trinity, de Tuléar,' Paxman would cry)
- Dandie Dinmont Terrier
- Giant Schnauzer
- Glen of Imaal Terrier
- Havanese
- Hungarian Puli
- Irish Water Spaniel
- Komondor
- Lagotto Romagnolo

- Lhasa Apso
- Maltese
- Mexican Hairless
- Miniature Poodle
- Miniature Schnauzer
- Portuguese Water Dog
- Russian Black Terrier
- Sealyham Terrier
- Soft-Coated Wheaten Terrier (like Brodie)
- Spanish Water Dog
- Standard Poodle
- Shih-Tzu
- Tibetan Terrier
- Toy Poodle
- Yorkshire Terrier

In addition, the following terriers shed only a little bit:

- Airedale
- Australian
- Border
- Cairn
- Cesky
- Fox (Wire)
- Irish
- Kerry Blue
- Lakeland

- Norfolk
- Norwich
- Scottish

Terriers rule.

Dog or Bitch?

There's no right or wrong answer to this, and an awful lot of generalizations, which are mostly true. For example, dogs (i.e. males) can be slightly more aggressive if they are un-neutered, and bitches can be slightly more malleable and easier to train. There's also a whole anthropomorphic layer that comes into play when people discuss this topic, along the dogs are from Mars, bitches are from Venus line: honest, guileless shmuck dog (bloody good bloke) v. wily, conniving minx bitch (piece of work). I don't really believe in any of it. Your dog or bitch will be easy or difficult depending on where you got it from, how well you've trained it and socialized it, and how much attention and care you are able to give it.

Having said that, bitches come into heat twice a year, for two or three weeks. During this time they have a kind of period – a bloody vaginal discharge, at any rate, that is attractive to male dogs. If you don't want her to

get up the duff, you need to keep her locked away from male dogs, somewhere with no carpets or upholstery to soil. You can of course have her spayed when she is six to eight months, at which point this whole thing stops being an issue. Male dogs get boners and try to hump things; this doesn't entirely disappear when they are neutered, though it is considerably helped (Brodie, who was done good and early, still feels the sap rising every spring). I think you can cut through this whole question by asking yourself whether you would be embarrassed if your dog had a stiffy or licked his genitals extremely thoroughly in public. It's really simple: if you wince at the fact that you can see male dogs' penises, you're probably better off getting a bitch.

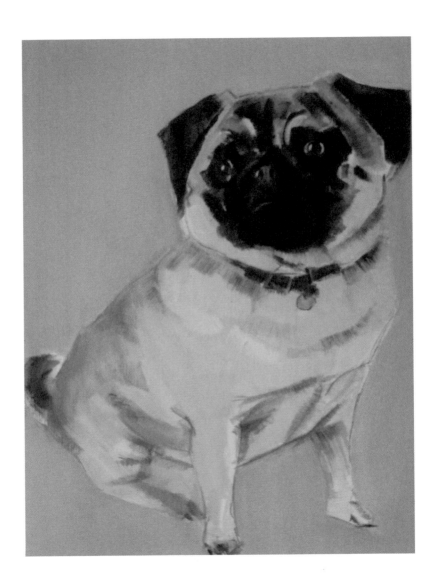

Chapter Three

PREPARING FOR THE PUPPY

This is a short chapter, because I've already explained the pros and cons and whys and wherefores of getting a pupster, so if you've bought this book and turned straight to this chapter, do consider turning back.

For the rest of you: there will be tremendous excitement, of course. I was *sick* with excitement before Brodie's arrival. I had two fairly sleepless nights directly before we went to Sheffield to pick him up, and prior to that I had had a fortnight of getting lost in dog merchandise websites online. It was all slightly silly: there aren't many things you actually need. But it was such fun.

One thing that really is important is deciding whether you want to crate-train your puppy or not. A crate is basically a big metal cage. This sounds incredibly bleak and unenlightened, but the reasoning is as follows.

Your tiny new puppy has only known his mother, his siblings and the house he was born in. He is now arriving in a whole new universe. Not a single thing in this universe is familiar (by the way, take an old towel or scrap of blanket with you when you collect the puppy and ask the breeder to rub it on his basket/family. He will find the smell highly comforting once he's at your house).

That's not only a lot for a puppy to take in, but also a lot for him to familiarize himself with. It's geographically confusing: new rooms, new items of furniture, new sounds, new smells, and that's before he gets to the business of meeting giant new people – you, who are his new family, whether there's one or ten of you. Now, your puppy will no doubt be an excitable, chipper sort, and

find all of this positively thrilling. But he is also a weensy puppy. He will get tired very easily. Wouldn't it be quite nice if there was one place that he quickly recognized as being *his* space, for him to quickly feel safe and secure in? That's the crate. Think of it less as a cage – a cage with an open door, I might add – and more as a cosy bedroom. The cosy bedroom contains a comfortable bed, a couple of toys and a bowl of water. Bowls of food appear (and are removed) as needed. When your puppy has had enough of hanging out, playing and being handled, he can trundle to this bedroom and take himself off for a snooze/snack/drink.

If you decide to leave him alone at night, rather than bringing him to the bedroom with you to do poos under the bed, then – well, look, yes: he will be sad. But he will be less sad in his (now-locked) crate bedroom than left to roam the vast, dark expanses of the night-time kitchen, having a good chew of stuff before curling up sadly under a chair. He'll be less sad the second night. By the third night, he might not mind at all: he'll be beginning to think, 'Ah, OK, so this is what happens when the lights go out: I go to my bed. Cool. I'll see everyone in the morning.'

The crate also comes in enormously handy if you have to nip to the shops for a minute and don't fancy leaving

the puppy free to roam/destroy; if you have visitors who
either aren't interested in the puppy (though, are they
insane? Why are they even there?) or require your full,
puppyless concentration; or if you're simply trying to do
something, like cook a meal or mop the floor, that isn't
helped by having a puppy under your feet (puppies *love*
chasing the mop). Once the puppy learns that the crate is
a safe, good place, he will be happy to be placed inside
it every now and then. (Do not encourage children to
follow him into it for a laugh – it's his space.)

Go for the biggest crate you can get, within reason –
there's no need to put a Peke in a crate designed for a
mastiff – so that you have three areas that are clear of
each other: one to sleep in, one to eat in and one to go to
the loo in. Because when it comes to toilet-training, the
crate will be your friend, especially if you don't have
immediate, speedy access to a garden. You line it with
newspaper and, if you like, supplement the newspaper
with those pee-absorbent puppy pads that are sort of like
flat dog nappies (kitchen roll would do just as well, as
would extra layers of newspaper), and when he goes
to the loo, you can clear and clean the whole thing in
seconds. This isn't to say that you won't find deposits
elsewhere – you *so* will – but training the puppy to use
the crate, and whizzing him back to that bit of the crate
when he crouches down to poo or wee, will *eventually*

yield benefits (see page 102 for the full low-down on house-training and encouraging good lav habits). Crates fold flat, so you can put them away easily when you've stopped needing them. Very important: never use the crate as a punishment. Do not stash the puppy away in the crate when you're angry with him. As you will shortly discover, dogs, even very young ones, pick up on every emotion. They are constantly looking to you to learn how to please you. If you are cross with the puppy and lock him in his crate, he will come – perfectly reasonably – to associate the crate with your displeasure. He will stop loving, or even liking, the crate. He will cry and howl when you put him in there. This buggers up the whole principle of the crate. Equally importantly, don't lock the puppy in the crate and then go away for hours. The crate is always a bedroom and never a cage. It is a safe space, not a jail. Make sure the door to the crate is open if you have boisterous child visitors, or very loud adult ones. The puppy may well want to get away from them. You might too, but try to resist the urge to follow him in.

The next thing to decide is whether you want to allow your puppy – and eventually your dog – on to furniture and/or beds. This is quite a vexed question: some people feel very strongly about it. It's partly a question of dog hair, partly a question of space – if you have only one

sofa, you don't necessarily want the dog to sprawl all across it every night; if your bed is quite narrow, three (or even two) can feel like a crowd – and partly a question of whether you consider sprawling dogs unhygienic in some way. In the country, it's also a question of minimizing the number of places where mud ends up. But really, it's mostly to do with how clear you feel the demarcation between dog and human ought to be. Some people think, '*I* am the human, *I* sleep in the bed, *you* are the dog, *you* sleep on the floor'; others think that there is nothing nicer than reading in bed with a dog curled up at their feet. Whatever you decide, be consistent: don't play with the puppy on the sofa if the sofa is at some point going to be become verboten. Gently put him back on the floor if he tries to scrabble up/hops on regardless. Equally, don't take a new puppy into your bedroom if you're going to boot him out again in three months' time. It's confusing for the dog, and dogs really hate confusion. In fact I would say that confusion is behind 95 per cent of 'bad' behaviours.

Puppy-Proof Your House

- If you're confining the brand-new puppy to one room while he's tiny, consider buying a stair gate. That way, he can see what's going on in the

rest of the house rather than being stuck behind a closed door, but he can't go scooting off to wreak havoc.

- If you live in a city and the road outside is full of traffic and vehicles, become really vigilant about using the stair gate and shutting the front door, even if someone's just dropping something off for two minutes.

- Get down on the floor and pretend you're a dog. Have a look for any gaps that a puppy could squeeze through and get stuck in behind furniture, and fix these before the puppy arrives.

- Don't have any electric cables running along the floor of the room where the puppy will be: he will chew them. Ditto trailing computer cables. Don't have lit candles at low level.

- If the room the puppy is going to be in has anything precious at or near ground level – including rugs – remove them for now. A clear, washable floor area is best and any precious ornaments on low-level tables are at risk of being knocked over. Look out for stray children's toys too – things like Lego pieces can be choked on, and beloved teddies make lovely edible friends/ snacks.

- Guinea pigs, rabbits, hamsters and other small pets will not be delighted by the arrival of the puppy. Move their cages away from the room the puppy's going to live in.
- Remember that dogs are massively allergic to chocolate, avocados, grapes and raisins, all of which can be fatal.* Your home is unlikely to have stray avocados lying across the kitchen floor, but you never know. Chocolate crumbs or raisins are less unlikely if you have young children. Sweep them up.
- If your under-the-sink cupboard is protected only by a curtain or a wonky door, move its toxic contents somewhere else. Needless to say, don't put the puppy in a room where he could access even a lone granule of mouse or rat poison.
- Don't keep toxic products, sharp things or machinery anywhere easily accessible in the garden; lock the garden shed.
- Keep your dog away from slug pellets and other poisons.
- Some ordinary garden plants are toxic to dogs; some can be fatal. The list is quite long and

* Please don't be too panicked reading this: your dog won't die if it eats a bit of chocolate – he will be pretty sick, but he will recover.

includes African violets, aloe vera, amaryllis bulbs, bluebells, daffodil bulbs, geraniums, onions, rhubarb leaves, tulips and so on and so forth, at frightening length. The full list is available as a downloadable factsheet from dogstrust.org.uk. Before you get into a complete panic and consider digging up your entire garden, I would like to say that our garden has daffodils and tulips and bluebells and a whole other load of plants that are hazardous. Brodie has never shown any desire to go anywhere near them. But you can't be too careful with a little puppy who wants to chew and explore everything: have a read of the list and certainly don't leave bulbs lying around at mouth level.

Things the Puppy Needs

🐾 **A puppy container** Sometimes you can have quite a long journey bringing the puppy home. We had a charming wicker basket with a little grille door, which doubled up as a mini-bedroom for Brodie's first few hours, but this was frankly extravagant – a sturdy box would do, although you can't see out of sturdy boxes. Whatever you use, stick an old towel in it to

make it cosy, and put several layers of
something absorbent on top of the towel.

🐾 **A dog bed** Don't go mad – it'll get really
chewed and ruined at this stage. Save the
super-duper fancy-pants dog bed for when your
puppy is older. For now, one of those moulded
plastic dog beds is perfect – he can chew it
without completely destroying it – and they
come with soft, fleecy liners that you can
chuck in the washing machine. Add extra
old towels or blankets as you wish, including
the mum-smelling towel/rag you have
hopefully remembered to procure from
the breeder.

🐾 **A food bowl and a water bowl** The water
bowl needs to always be out and always have
fresh water in it; the food bowl needs to be
washed and dried after each meal. Get
something that doesn't slide around and that
isn't too deep – the puppy shouldn't have to
plunge half his head in to eat or have a drink.
Those grippy (with rubberized edge) stainless-
steel bowls are very good. I also like the
traditional Mason Cash ceramic ones
that say DOG on the side, though note these

are deep and have straight edges, which make it harder for tiny dogs to get into the corners properly. Something shallower is a better bet initially.

🐾 **A collar and lead** You don't really need a collar and lead at this very early stage, but buying these items is part of the fun of the whole thing. Make sure the collar's very soft – fabric rather than leather – and only put it on for a couple of hours a day at first. You should be able to slide two fingers between the collar and the puppy's neck. Puppies grow incredibly fast: keep checking. My favourite leads and collars are on page 226.

🐾 **Biodegradable poo sacks** And plenty of 'em. If you have fitted carpet that you can't wash easily, you will also want to buy wee-and-poo-scent remover. Yay.

🐾 **Dog treats** The breeder will give you food to get you started, but do stock up on dog treats. I have strong views on what to feed your dog, which I lay out in detail in Chapter Five. For now, please get all-natural treats that are marked as suitable for puppies. We use tiny little scraps of dried liver that we buy from the

pet shop. These treats are nice for the puppy, obviously, but more to the point they are your number one tool in training the puppy from the outset.

🐾 **A vet** You need to register with a vet if you aren't registered already. Ask around for recommendations, and go and fill in the paperwork so that the admin is done before you get the puppy home. Vets vary wildly, even within one neighbourhood. It's a good idea to discuss options with local dog owners.

🐾 **Pet insurance** If you've bought a pedigree puppy from a reputable breeder, the puppy will have already been registered with the Kennel Club. You'll get given some bumf when you collect the puppy; this will usually include free trial pet insurance. Take it up. If you don't feel you're getting the best deal, you can always hunt around online later. Don't buy cheapo pet insurance from your supermarket, by the way – it barely covers anything and ends up being the opposite of a bargain.

🐾 **A phrase . . .** you're going to stick with for ever that means 'Do a wee or poo now.' You will use this phrase throughout your time

toilet-training your dog, and for expediency if you're out and in a hurry. Think about it carefully. We chose 'Wee-wees outside.' I honestly can't begin to imagine why: it's literally the worst phrase in the world and we very quickly came to regret it bitterly. It sounded unbelievably naff within about a week of it first being deployed, and also I wanted to cry laughing when my Scottish partner said it in his really deep, masculine Scottish voice, but by then it was too late. I would feel the same way about 'Do your business' (waaaah) or 'Go toilet', although at least 'Go toilet' has a blunt, unadorned honesty to it. As I used to stand on pavements with Brodie, waiting for action while creepily murmuring, 'Wee-wees outside' over and over again and wanting to sob with shame, I wished I'd used something like 'Poos in the WILD!' or 'Time for the lav.' So. Think about it carefully. You'll be saying it for years, and often in public. Wee-wees outside! I can't even bear to type it. There's never a good time for a coy euphemism, really, in life.

A name tag Though again he hardly needs a name tag while he can't go out because

his vaccinations haven't kicked in yet, if you're anything like me you'll want to get one anyway. Pick something sturdy that won't buckle or scratch, and don't put it on as soon as the puppy gets home – it's just another weird thing for him to get used to. Wait a couple of weeks and then introduce it (and the collar) in short bursts. Good name tag suppliers are on page 273.

🐾 And, almost most importantly of all, the puppy needs **a name**.

Dog Names

I've always found the idea of dogs with human names deeply pleasing and funny. The names need to be really solid and slightly old-fashioned: there's nothing wrong with the name Jack, for instance, but it isn't – to me at least, and I do see how monumentally subjective these things are – as pleasing as a dog being called Paul, Andrew or Patricia. On Twitter, @hollygolightly once told me that her upstairs neighbour's tiny dachshund was called Filippo. Oddly enough, I also know a Westie called Giovanni. There's something to be said for a debonair foreign name. One of my sons was very keen on Brodie

being called Pierre, though to my mind Pierre is a poodle's name.

Beware of going too far down the nostalgia route: if I were a dog, I'd get the joke if I was called Dave, but I wouldn't really love being called Egbert or Nigel. I would feel belittled, like I only existed as the butt of a try-hard joke. It's not respectful. Having said that, Ian (my delightful brother-in-law notwithstanding) strikes me as being an excellent name for a dog, and imagine a Scottie called Alastair. Mind you, I can also picture a Scottie called something like Cecil or Aubrey. That Scottie would have an unexpected hinterland and possibly own a smoking jacket.

Don't call your dog anything your friends have called their children, or might conceivably call their children in the future. It's slightly passive-aggressive. Or aggressive-aggressive, to be honest. Mind you, I say that as the mother of an Oscar, an Archie and a Nell, which are all popular dog names. I take this as a compliment. But some straightforwardly, contemporary human names can be quite odd, particularly the feminine ones: Emma, or Juliet, or Victoria would cause me to look at the owner and think, 'Gosh, really?' I suppose what I'm saying here is, don't name your dog what you'd name your baby. People will, rightly or wrongly, judge you.

Do not name your dogs after your exes: for example,

James Gregory Cooper. It *is* quite funny, but you'll tire of the joke. Dog naming needs to come from a place of good karma. Do not name your dog after something or someone you don't like.

Beware also of tiresomely 'wacky' or 'humorous' names. They can strike others as the dog-naming equivalent of an amusing sign in an office. There are an awful lot of blond, shaggy Labradoodles called Boris, for instance. Har har. Don't call your dog Cat either. It's really not funny.

Try the name out before bestowing it – go outside and shout it in public, and see how comfortable you feel. Three syllables can feel a bit of a mouthful and are likely to be shortened. Two syllables work better than one for recall purposes – John or Pip, for instance, are too terse

to call out properly. You'd have to call 'Jo-ohn' or 'Johnny', or 'Peeeee-ip' or 'Pippy'. Roaming the park shouting 'Pippy' may or may not be your bag.

A surname as a first name can sound very smart. If you have a smart-seeming dog, do consider this (also works perfectly if your dog is scrappy and scruffy: adds gravitas). Don't be constrained by using your own name: any surname you like the sound of would do. I am especially fond of butler-sounding names: Carruthers, say, or Crichton. And there's a lot to be said for the simple integrity of Smith. Also: Peabody, but my daughter tells me I've stolen that from some cartoon or other – I thought I'd cleverly invented it. Still, brilliant name. I also like Boothby.

Be careful of anything *too* adorable and puppyish: the adult dog has to carry the name too, and he has his dignity. This applies especially if you let your smallish children name the dog – realistically, you're going to be the one walking him and calling out 'Mr Blossom' or 'Fairycake'. If your small child is persistent, suggest using their chosen name as a second name, thus Carruthers Rainbow, for example. The second name can then be deployed in moments of especially intense emotion ('I love you, Carruthers Rainbow').

Names that make fun of the dog's shortcomings seem a bit mean. I'm all for naming a minuscule dog Goliath,

because it endows him with might, but that's not the same as calling a sweet, shy, slightly timorous dog Lucifer, or a tubby dog Alexa. There's no need to be sarky. Dogs don't understand sarcasm, only love.

Having chosen a name, stick to it. It is confusing for everybody if you change your mind and decide that Percy is in fact now called Toots.

Another thing: don't pick a name that sounds like anything you might use as a command when training your dog. So, for instance, if you know you're going to say 'Stay' or 'Go' or 'Walkies', don't call the dog Stacey or Gobi or Walkyrie. Which I know you won't, because those are truly terrible names, but still – it hadn't occurred to me until I met a dog called Norah, who didn't really seem to understand the word 'no' ('Yes, Norah! Good girl! Norah, no' – so confusing. They *did* change her name, in the end, and everything was fine).

One last, very important thing to bear in mind before you go and collect your new puppy: pick a good day. In fact, pick a good week. Don't pick a week where you're frantic at work, or a day when you have six people coming to supper. Don't pick a day when three children are having friends over to stay, or when the builders are moving in, or when you know you're going to be stressed because X or Y is happening. Fridays are good, because

you're at home all weekend. In order to have a happy, well-behaved dog, you need to make yourself available to the puppy right from the start. That means trying to clear a bit of time in which to devote yourself to his needs at this earliest of stages. This is a slight pain now, but you will be *really* glad you did it as your puppy grows older.

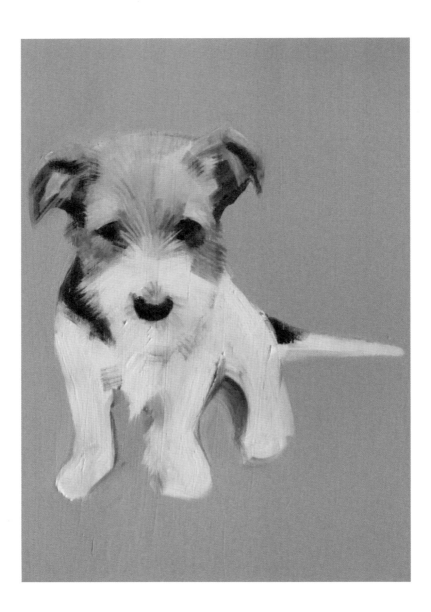

Chapter Four

GETTING
THE PUPPY HOME

The main thing to remember is that the puppy will be utterly astonished at best and completely freaked out at worst. Consider: he's only ever known the company – and comfort – of his mother, his siblings and his breeder. He is only used to one geographical space. He only knows one set of familiar smells. Now you come along, swinging your puppy basket, and breezily take the puppy away from all this. As we were preparing to leave the breeder's house, we nearly cried at the thought of the puppy never seeing his mum or siblings again. I don't think we're especially wet or sentimental people, but it felt momentous (slightly monstrous too, to be absolutely honest).

Imagine how it felt for the puppy. He was taken by two strangers, placed in a basket and then on to the floor of a waiting taxi. Then he went to the train station,

boarded the carriage and spent several hours on a table, squeaking, as the train chugged along and we made soothing noises. Then another taxi, and finally home – to three highly over-excited children, though all of them thankfully old enough to get the idea that the puppy might be feeling totally nervous and scared.

If you have young children, prime them and prime them well in advance. If you explain the puppy's emotional journey to them – maybe go easy on the 'and he will never see his mummy again' bit – they will be able to imagine it perfectly, and will hopefully adjust their behaviour accordingly (drawing comparisons with their very first day at school or nursery can help). The puppy, initially at least, needs peace, calm and gentle handling. That means not being welcomed home with hysterical screams of joy and party tooters going off in his face.

Children and Dogs

Teach children – either yours or visiting ones – never to do ANY of the following things under ANY circumstances, either with your own dog or with anyone else's:

🐾 **Startle a dog** Anything the dog isn't expecting – tail pulling, poking, screaming in his face – will be

startling to him. His response to being startled will be aggressive.

🐾 **Go anywhere near the dog's food**

🐾 **Tease a dog** Children, even quite old ones, love teasing dogs. Dogs really hate being teased. Teasing includes anything designed to make the dog 'smile' (bare his teeth), jump up, bark, howl or whine. Tormenting a dog with a treat, and then not letting him have it, is also teasing. The dog will end up snapping. The child will scream. Now you have a dog who doesn't like children and a child who's scared of dogs. Appalling result.

🐾 **Hug a dog** Do not hang off his neck. Only pat the dog with the owner's permission, and under the owner's supervision. Pat gently.

You must not leave a young child alone with a dog they've only just met – no matter how lovely the dog seems to be. The friendliest dog in the world can bite if he is annoyed beyond endurance. If your dog is tormented, as he sees it, by over-enthusiastic, over-loving small children, he may become the sort of dog that doesn't like children. This would be a terrible shame for everybody, children and dog included. Teach your children to treat the dog with respect from the outset.

*

So, you have a corner of a room set up. Put the puppy basket, or carrying box, or whatever you're using, down gently on the floor. Open its door. Sit down on the floor too, so that none of you are looming gigantically over the puppy. You may find that the puppy pelts out excitedly, or you may find that he just sits there peering out for a bit, finding his bearings. Give him time. You could, at this point, lure him out with a treat, but it's perfectly fine, and I think preferable, to just let him decide without bait. Eventually the urge to explore his new environment will become overwhelming and the puppy will emerge of his own free will (try not to stick your phone camera in his face straight away). Stay sitting on the floor. If he heads for your lap, cuddle him. If he sniffs about first, let him. Show him where the water is – pick him up and take him over, he'll probably be thirsty. And then just hang out with your new puppy. It is fine to pet and kiss him, but gently, and not all at once. Resist the urge to *do* anything to the puppy at this stage, such as put a collar on him, comb him, groom him. Just let him mill about.

Very little children should be introduced in a supervised way and urged to contain their excitement: no grabbing, yelling or sudden lurches, and see the list above too. Put the puppy on the child's lap and ask the child to give him a treat, and take it from there. Puppies have extremely sharp teeth and they *will* bite if truly alarmed.

Even if they're as happy as Larry, their inbuilt urge to chew can still feel quite nippy. Forewarned is forearmed. Do not ever leave toddlers or young children alone with the puppy.

If the puppy does nip, which frankly he will, a good response, especially though not exclusively from a child, is to make a sad, distressed squeak. This is what the puppy's siblings would have done over the past few weeks of rough and tumble play, and the puppy, who after all only saw them a few hours ago, will recognize the behaviour. The siblings would also have nipped back, but that's not a good idea here. When the nipping occurs as part of a game, the child should say 'No' and silently turn its back to the puppy, so the puppy can't see its face. This won't be effective at first, but it will become so later. The alternative is walking – not stomping – calmly away. The puppy wants to play, so if a behaviour inhibits or interrupts the playing, he will gradually learn to abandon that behaviour. An important thing to remember: a puppy who learns that nipping gets him attention, or gets him what he wants, may turn into a dog who nips to communicate his needs. Nobody wants that.

Having said all that, be forgiving of your puppy. I think a lot of people expect puppies to be like toys crossed with 3D cartoons – frolicking adorably, gazing adorably with heart-melting eyes, falling adorably asleep

at one's feet. Puppies do absolutely do all of these things – and your heart will explode with love. But they're also perfectly capable of being a pain or a nuisance. They are very like babies in this respect, and nobody would call a two- or three-month-old child 'badly behaved' or 'naughty'. They are simply a baby. Or, in this instance, a puppy, doing what puppies do.

When Brodie was a new puppy, my partner would go out to work in the morning, come back in the evening and politely inquire about my day. Had I got much work done? Gone out to lunch? Met a friend? Gone shopping? I would look at him with the utmost incredulity. 'Well, no,' I would say. 'Not really. Because, Brodie.' And he would chuckle at the mad idea that this little scrap of fur with massive square paws could possibly put the stoppers on my day. He thought I was exaggerating. I wasn't.

He did put the stoppers on my day. First, he chased my daughter – or rather my daughter's delicious, hugely appealing shoes – round the kitchen at breakfast time. He was either *on* her shoes, chewing merrily, or trying to *catch* her shoes, nipping her ankles wildly as he went (I think he may also have been trying to catch the frill of her socks). She didn't much care for this behaviour and, once the grazes and scratches got too much, ended up sitting on, rather than at, the table. Then we'd be getting

her book bag together and he'd choose this moment to do a poo. I'd feel bad about not having accurately predicted the poo. While I was cleaning up the poo, the toast would burn and the smoke alarm would go off, causing the puppy to go (even more) bonkers. Older children would then appear and vigorously cuddle the puppy, causing him tremendous excitement. He would express this excitement by racing about like a loon, literally getting under everyone's feet, to the point of tripping them up. Our kitchen was very small, and it used to strike me as remarkable that the smallest creature in it occupied such a lot of its space.

Then everyone would go to school, and Brodie and I would hang out. I'd take him outside – remember, he wasn't fully vaccinated yet, so I could only take him to our own tiny back garden – for a wee ('Wee-wees outside,' ugh) that usually didn't appear until we were back inside. This garden, unhelpfully, was down a steep metal staircase with open gaps between the treads, so I couldn't just leave the back door open and toilet-train him that way – he'd have fallen to his death. Life would have been monumentally easier if the garden had been on the same level. On the other hand, plenty of people keep dogs in flats. But certainly if you have immediate access to an outdoor space, your puppy life will be simplified by a gazillion. If you're about to move from the third floor to

a garden flat, seriously – wait until you've done it before getting a puppy.

HOUSE-TRAINING

The basic first steps for weeks one to three involve taking your puppy outside:

- First thing in the morning, as soon as you get up.
- As soon as he wakes up from one of his many naps.
- Five minutes after each feed.
- After you've played with him.
- After anything tiring, like exercise.
- After anything exciting happening (e.g. visitors) or unusual or new (e.g. hoovering).
- *At least* once an hour.
- Whenever you see him circling or sniffing or getting ready to squat.
- Before you go to bed.

He will potter about and sniff around. Don't try to hurry him up. When you see he's getting ready to go to the lav,

say your chosen phrase, so that he associates the phrase with the act of weeing/pooing. Praise him LAVISHLY when he's finished.

If you find him going to the loo in the house – and you will – say a loud, emphatic NO and skip gaily towards the garden. He needs to follow you himself, not be carried by you. Say the chosen phrase. If he 'goes', praise him lavishly.

The more you are able to keep a fixed, beady eye on the puppy, the less he will have 'accidents'. It's really a full-time job for a bit – if you can't do it all yourself, enlist help. Most puppies are fully house-trained by the time they're six months; for most it happens much, much sooner (Brodie was about three months, I think). The more you concentrate on this when you get him home, the faster it will happen. If I'm making it sound like a job, that's because it is. Please, please don't give up on toilet-training your dog. Dogs that aren't house-trained are a nightmare: you can't take them anywhere and nobody likes them, or you for turning up with them. Don't be the person of whom people say, 'Ugh, she's coming round again with that bloody dog.' It's really unfair on the dog, and also to be honest it's utterly revolting.

I'd go about the rest of my day, working from the kitchen table, but it was really quite difficult to concentrate on anything fully. I thought I'd puppy-proofed the kitchen adequately, but *everything* was a thrilling discovery for Brodie. The skirting board. The table legs. The toy basket, which he soon learned to sit in, surrounded by the mortal remains of beloved teddies. The small, inviting spaces behind the fridge or the chest of drawers. Also, I wanted to kiss him and play with him all the time, which was, obviously, monumentally distracting. This combination of intense love and mild irritation reminded me of being at home with a new baby – as did the constant vigilance re the poo and wee situation – and I felt bad for having in the past laughed cruelly at people who'd claimed that having a new puppy was awfully like having a new child. I used to stand behind these people and roll my eyes while making 'delusional lunatic' faces. Now I was one of them.

Having a puppy is also like having a child on the 'things people don't tell you' front. Puppies are so overwhelmingly adorable that owners of older dogs forget that they once bought chaos and anxiety into their lives. But I remember. There's a fair bit of stuff I wish I'd known, and most of it is to do with the importance, and correct deployment, of treats.

I thought – and this probably says quite a lot about my relationship with food – that treats were, basically, pleasant extras, offered as an expression of love or approval, or as a nice mid-morning snack. I didn't think they were a ninja tool. But they are. They are also an expression of love. The combination of love and ninja is MIGHTY. And I wish I'd found this out earlier. There's a whole chapter on training coming up, but here are the basics that you need to know for now.

Most basic basic of all: dogs respond to love. They respond to love better than they respond to anything else – and that means they respond to love immeasurably more, and better, and more effectively, than they respond to fear. Who doesn't?

This little puppy, getting under your feet and charging around exploring his new world, wants to make you happy. He is constantly looking to you for clues about how best to achieve this. A treat is a visual confirmation of your approval. If the puppy does something good, be very quick to praise and reward him – and I mean *very* quick: the praise and reward need to be instant, otherwise he will not know what you are praising and rewarding him *for* – getting hold of your best scarf and trying to eat it, or peeing on the newspaper/in the garden rather than on the rug.

The puppy is too young to learn how to behave

impeccably. But he is not too young to learn to make the association between good behaviour and reward or praise. By the way, you're not going to have to keep carrying pocketfuls of treats around with you for ever, until your dog grows huge and spherical: the greatest treat you can give your dog is not a piece of dried liver but a stroke and a cuddle. For now, though, supplement those with treats. You don't need a whole big treat either – tiny broken-off bits of treat will do, and will ensure that the puppy doesn't get fat. Which leads me neatly to the question of what to feed him. There's much more about treats and training in Chapter Six.

OLD SHOES

One tip: your puppy will be chew mad, when you get him home and later, when he's teething. He will seek out your shoes, even if they're on your feet, and try to give them a good old gnaw at every possible opportunity. Do not make the fatal mistake of giving your dog an old shoe to chew. I did this, congratulating myself on how

clever I was to give him what he wanted at no ruined-shoe cost to me. It didn't occur to me at the time that obviously dogs can't differentiate between shoes it is OK to chew and shoes that need to be left alone. Hunkered happily with someone's old trainer, Brodie learned that chewing shoes was allowed, and it took quite a while to undo that lesson (not entirely successfully, I have to say).

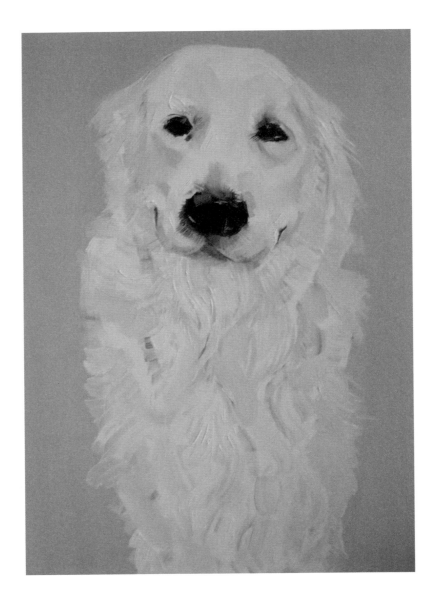

FEEDING ALL DOGS (NOT JUST PUPPIES)

Dogs, as we know, are evolved from wolves. Their closest ancestor is the grey wolf, *Canis lupus* (the domestic dog's Latin appellation is *Canis lupus familiaris*). Grey wolves have been around for about 4 million years. During this time, they have eaten biologically appropriate food – mostly meat and some vegetables, plus some other stuff that I'll get to in a minute. Humans started domesticating wolves at some point between 8,000 and 20,000 years ago, and gradually those wolves became dogs. Over the centuries, we've bred all sorts of traits and characteristics into them, hence the wide variety of dogs we know and love today. We have altered their faces, the length of their limbs, the feel of their coat, the size of their bodies and, on occasion, their temperaments. But we have not altered their internal organs or digestive systems.

Dogs still have knife-sharp teeth, because these teeth are made to chomp and saw through flesh and bone. If you were to take even a very pampered, lapdoggy domestic dog and leave him to fend for himself in a field, he would eventually chase, catch and eat smaller animals, like rabbits and squirrels, and he would not fillet them, skin them or debone them first. If he found the carcass of a larger animal, he would tuck in with relish, and probably eat its organs and stomach contents to boot. Lots of dogs do this without being asked: they chase a rabbit and – chomp, crunch, burp, thanks very much, any chance of seconds?

Dogs' jaws cannot move from side to side, only up and down, which means they cannot grind food. They also have no digestive enzymes in their saliva. What this means is that they gulp their food down whole, or in the manageable chunks you have helpfully dished up for them. Crucially, the whole digestive process takes place after they've swallowed/gulped it down. It all happens in their stomachs. (We humans have digestive enzymes in our saliva; the digestive process is completely different and starts in the mouth.) Dogs' stomachs contain violently corrosive acids that are strong enough to dissolve bone: if, for some peculiar reason, you had access to a dog's stomach acids and stuck your hand in them,

you'd burn it badly. This is as it should be, since wild dogs – and wolves – derive a great deal of their nutrition from bones. They also never have an issue with manky or mossy teeth, gum disease or bad breath, but I'll get back to that.

Wolves are carnivores. This means that it is biologically appropriate for them to eat a diet that consists of mostly meat. It is the diet they need to thrive. They could *survive* on another diet – as millions of dogs do – but they would not be fully well, because that diet would not be *optimal*. You and I could probably survive on custard creams, but there would be fairly severe consequences. And we might conceivably feel like prats if we went to the doctor, full of custard creams, and complained that we weren't feeling 100 per cent.

Now, there is no difference, scale aside, between the internal organs and digestive system of the fluffiest lapdog and that of the grey wolf, with whom all dogs share 99.96 per cent of their DNA. None. Dogs are wolves on the inside. Carnivorous wolves, anatomically designed to eat meat and bone. If they don't eat the diet they were built for, they are not eating what is best for them. Who doesn't want what is best for their dog?

Dogs in the wild also eat grasses and vegetable matter. They will eat rotten fruit, and, as I was just saying, also

the partially digested contents of their prey's stomachs. This is not an appealing thought, and the next one is even worse: even domestic dogs will – as you may know if you already have them – sometimes eat faeces or vomit. This is gross, but both of those substances contain protein, fatty acids, vitamins, minerals, antioxidants, enzymes and fibres. This, by the way, is why your dog – who only eats the special, super-duper, expensive packaged food you lovingly buy for him – will sometimes make a beeline for something unspeakable in the park or on the pavement. He's trying to resupply himself with the foods his body naturally needs, like people suddenly craving bananas when they're low on zinc.

Next thing: dogs don't eat grain, because doing so affects the pH balance of their stomachs and, in brief, makes it difficult for digestion to occur properly. They can tolerate small amounts of processed grain, but they don't tolerate it especially well. It all comes out in vast volume at the other end and, not to put too fine a point on it, this is why dog shit is so disgusting and often so distressingly copious. Just hold that thought for a bit – we'll get back to it. By the way, when you and I eat grain – or indeed any carbohydrate – our bodies convert it to sugar, which it then stores and uses as energy (or turns to fat if we ingest too much/don't move about enough). Dogs' bodies cannot do this.

You can see where I'm heading. I think that commercial dog food is basically junk food. It was invented by an entrepreneurial former electrician called James Spratt in 1860 and called, rather fabulously, 'Meat Fibrine Dog Cake' – Spratt got the idea for it from watching a bunch of hungry dogs wolfing down ship hardtack (hard biscuits for sailors) in Liverpool docks. His first biscuits were made out of blended wheat meals, vegetables and non-specific 'meat', provenance not supplied (Spratt, to his dying day, never said where his meat came from).

Given that dogs had until then been fed bones and table scraps, his new product had massive upwardly mobile, class-based appeal: you set yourself above the common herd if you could afford to buy it, rather than having to make do with what you had at home. Spratt's first customers were British dog-owning gentry, but he soon expanded his empire, all the way to America. Soon, every loving dog owner became convinced that they'd been feeding their healthy, robust, rarely ill dogs wrong all along, and what they really should have been doing was feeding them ... biscuits. BISCUITS! It seems bonkers in retrospect, but Spratt's were by now rich, savvy and persuasive. They put up the first ever billboard to appear in London. They came 'By Appointment to Queen Victoria'. They had the American Kennel Club in

their pocket. They had a brilliant logo, with SPRATT'S spelled out in the shape of a Westie.

People loved their dogs, then as now. Even the poorer ones somehow found the money to do what they thought was the right, dog-loving thing. Spratt's continued to thrive and expand. In addition to a growing range of animal food, it also made purging pills for the (human) bowel, hair-growth potions and an antiseptic shampoo for dogs called, pleasingly, Fomo.

Fast-forward and you almost yearn for the days of James Spratt. Today's commercial dog food is packed to the brim with 'meat derivatives', which can mean beak and eyeball, as well as diseased and unhealthy tissue, padded out with grains, ash and sugar, with additives and shelf-life enhancers whacked in for good measure, so that this creepy food can basically sit in its tin or pouch pretty much for ever and never go off. Canned and pouched dog food is, to my mind, the equivalent of raising your children on El Cheapo burgers made of dodgy beef and dodgy additives, every day, for the entire course of their natural life. Worse, it's like doing all of that and then loudly wondering why your dog seems so unwell, with his diarrhoea, his itchy skin, his weeping eyes, his constant ailments and infections and arse issues and trips to the vet – and, eventually, his more sinister, unnatural-seeming, life-terminating illnesses.

Not that I think biscuits – which is what kibble is – are any better. Dogs aren't designed to eat biscuits, or any kind of dried, baked food. It doesn't matter if the biscuits are lovingly hand-crafted out of kale and organic this or that. They're still biscuits. Would you feed your kids an exclusive diet of biscuits for their entire lifetime, even if the manufacturers claimed they were wholesome, 'healthy' biscuits?

There's a giant conspiracy theory around all of this subject, which normally I would roll my eyes at, but which I am reluctant to dismiss completely out of hand. You should at least be aware of it. It is this: pet food is a massive business, currently worth £2 billion a year in the UK, and rising; one recent forecast estimates that, globally, it will be worth just under $75 billion by 2017. Giant pet food manufacturers like Mars, Nestlé, Del Monte, Procter & Gamble and Colgate-Palmolive have very close relationships with veterinary colleges. In some universities, lectures on veterinary nutrition are sponsored by pet food manufacturers. And of course any research into pet food is conducted by, er, pet food companies, who always conclude – surprise! – that commercial pet food is just the ticket, fine and dandy, A-OK.

Add to that the fact that vets are not well paid. They almost all supplement their income by selling pet food.

The pet food in question is – also surprise! – always made by the giant pet food manufacturers in their various guises, who as well as lectures also sponsor all sorts of interesting vet conferences and vet events. Plus, obviously, healthy pets don't need vets, and pets' health is largely determined by nutrition. QED.

Or not. Who knows? I don't think vets are corrupt bastards lining their own pockets – I think they're largely amazing. But I do know a couple who, off the record, don't entirely disagree with aspects of the theory above. Either way, I'm sticking to known facts, and what known facts – as well as instinct – tell me is that I do not want to feed my dog any of this dog food – not canned, not pouched, not foiled, not baked. I don't believe in it. I don't even believe it's really food. Plus, I do not want to dish out food that makes me physically retch, or whose expiry date is ten years away. I want to feed my dog recognizable *fresh* food that doesn't disgust me. I don't think that's remotely unreasonable. There isn't a creature alive that doesn't thrive on fresh food. Why on earth should dogs be the exception?

Processed dog food can legally contain:

🐾 **Grain** As we have already seen, this is useless and comes straight out again.

🐾 **'Crude fibre'** Described as such because it is of

such poor quality, this is peanut shells, beet pulp and so on. Nutritional value = zero, but it bulks things out.

🐾 **Chemical preservatives** 'No preservatives' may gladden your heart, but it means either that the food has been heated so high that preservatives aren't necessary or that its raw ingredients were preservative-rich in the first place.

🐾 **Colouring** All processed dog food is grey sludge. It needs colouring to make it look halfway palatable. Several artificial colourings that have been linked to behavioural difficulties in children are approved for use in dog food.

🐾 **Chemical binders** These make the sludge form into pellets (kibble).

🐾 **Bad fats** These include tallow from rendering plants.

🐾 And, of course, those **'animal by-products'** – heads, hooves, eyes and so on. 'Animal derivatives' are hearts, lungs and other organs. I don't personally mind this that much. What I do mind is the tragically poor quality of the meat in the first place. I don't want or need to feed my dog fillet steak, but I would like the meat he eats not to be pumped full of growth hormone and other chemicals. I know what those meats would

eventually do to my family. I'm not OK with them doing it to my dogs.

Now, look: your dog isn't going to die if you feed him the odd tin of dog food. It's perfectly fine, every now and then, just as it's fine for a human being to suddenly have an uncontrollable urge for a Big Mac. Nothing awful is going to happen, and he'll probably find it unbelievably delicious thanks to the yummy additives and flavourings. My own reasons for choosing to feed my dog a raw diet are to do with logic and health, and above all results. He is a ludicrously healthy dog. His hair is shiny and soft. His skin is smooth and untroubled by itches. His ears are clean. His teeth are bright white and sharp as daggers. His breath is lovely. He never farts. He has no allergies. Nobody has ever had to (gag) squeeze his anal glands because they're blocked or sluggish. He hardly ever goes to the vet. He is in incredibly good nick, and I put this down to – apart from my superlative loving care, obviously – his diet.

RAW-FED POOS

When I first read about this way of feeding dogs, and of the potential health benefits, I was completely persuaded. I was also a bit scared. What if it was actually mad? What if it was the equivalent of having raised my children on kale juice and quinoa, and of being one of those bonkers people who scream at cake unless it's vegan and made of beetroots? But then I decided to give it a try and see – and comforted myself by thinking that kale juice and quinoa, monstrously unappealing as I find both, are still better for you than daily 'chicken' nuggets with a side of Fangtastics.

The thing that absolutely swayed me was the question of poos. I'd recently had to pick up an impressive, explosive load of diarrhoea, halfway up Primrose Hill in London – feet away from David Walliams as it happens – and of course with diarrhoea you *can't* pick it up, you just have to do these terrible ineffectual smeary scoops while heaving and wanting the ground to swallow you up. God, it was hideous. (I had a similar situation in the queue for a lovely burger restaurant in St Ives one

summer. Everyone waiting for their supper by the water's edge, hungry as can be. Cue the woman with the dog who basically shits a river and then potters off, besmirched, while she tries, and fails, to clear it up.)

Anyway, everything I was reading about raw feeding was postscripted by a joyous rave about small, firm, odourless, manageable poos. On one particular forum, I even read about a man who walked the dog, absent-mindedly put the poo sack in his pocket – a shocking, unthinkable concept for anyone used to 'normal' dog poo – and *forgot about it for a few days*. THE POO WAS SO SMALL, FIRM AND ODOURLESS THAT HE FORGOT ABOUT IT. 'Come *on*,' I thought. 'That's too much. This man is lying. He is a dirty liar from Liarsville, the liar.'

Reader, he wasn't. I have never put a raw-fed poo in my pocket, but if I did, I can understand how I could forget about it. I am completely serious. It's extraordinary, actually (it also makes perfect sense, as you will know if you have ever placed yourself on a very low-carb diet). Even better: dogs have these bum glands – I'll just pause here while you push your lunch away – anyway, these bum glands, which contain a substance that is secreted when they poo, and which marks their territory. These are designed to empty when a dog does a poo, at which point, hurrah, and you don't have to think about

anal glands again: they're looking after themselves. But. In order to work properly, these glands assume a certain firmness – hardness, even – of stool. When a dog's poos are too soft, as dog poos are when they are fed a processed diet, the anal glands can't empty properly, because their emptying is to do with the pressure put on them by a firm poo as it's pushed through. So then they stay full, or full-ish, and that is why some poor dogs drag themselves across the floor on their bottoms until the unfortunate vet or groomer has to squeeze the bum glands manually. Raw feeding knocks that right on the head. Anal glands: nae bother. And if that doesn't tip you into 'Oh, OK, I'll give it a go,' then really, I can't help you.

Oh, and another thing: the absence of any chemicals in the raw diet is very good news for your lawn – no more yellow patches.

Final thought: raw-fed dogs poo less frequently.

Raw-feeding dogs – often called the BARF diet, which stands for either Biologically Appropriate Raw Food or Bones and Raw Food – was popularized by an Australian vet called Ian Billinghurst, who in 1993 wrote a book called *Give Your Dog a Bone*. In it, he said that as

a vet he kept seeing dog patient after dog patient with the same grim issues, none of which was easy to treat. He thought he'd try a preventive approach, and started feeding his own dogs raw meat, lots of raw meaty bones, and odd bits of veg and peelings – the kind of food, in fact, that dogs were fed for hundreds of years, before Mr Spratt and his wretched biscuits came along. (Billinghurst is hardcore – he chucks entire chicken carcasses into his yard, along with various bits of giant animal – heads and things – but then I guess Australian yards are larger than British ones, and Australians less squeamish.) Then he started suggesting the diet to his patients. Result: eradication of common complaints; dramatically healthier dogs.

If this topic interests you, *Give Your Dog a Bone* is very much worth a read, though be warned that it does not hammer its point home with subtlety. There are also

all sorts of online groups, localized Facebook groups and so on too, most of which are extremely friendly if you have questions – just google 'BARF diet' or 'raw feeding'. Be aware that some people consider raw feeding a kind of religion, and that there's sometimes a degree of fanatical one-upmanship involved. Ignore all of that, but don't ignore the fundamental theory. There's also a book by a British vet called Tom Lonsdale entitled *Raw Meaty Bones: Promote Health*, which, despite its grammatically annoying unnecessary colon, is heavy on actual research.

Anyway, here's how to do it. As I was just saying, remember that this is how all dogs used to be fed before Mr Spratt and convenience dog food came along.

- At its most basic, give your dog your scraps, both raw and cooked. These should be mostly meat, with the odd bit of veg. Hold the salt. Always supplement this with RAW meaty bones. Cooked bones are dangerous because they can splinter – raw bones are bendier because they are still moist, as opposed to all dried out. Never give a cooked bone. Never give a spindly little bone full of jags either, obviously. Chunky is best. Choose a bone that's too big to gulp down, about the size of your dog's head.

- You will note that this way of feeding your dog doesn't cost a penny (any good butcher will give you free bones). It's free. But you will also note that you're giving your dog cooked food. It's still a million miles better than anything processed, however. If in doubt, start here.
- Go one better and give him food that's biologically appropriate. This means giving him a diet comprised of two-thirds raw meat and one-third raw veg – any veg except raw potato. You can chop or dice the meat (don't make it all gristle, obviously). Cheap cuts are great. The veg can be whizzed in the food processor and the two mixed together. Also give RAW meaty bones every couple of days.
- Bones are a toothbrush. Forget 'dog toothpaste', or those ridiculous dog toothbrush snacks made out of that sinister brown stuff, or those plasticky chews designed for 'dental health'. Your dog is a dog. He doesn't need plastic chews. A bone is his very own dental hygienist – plus it keeps him occupied, plus it mentally challenges him, plus it'll take care of his gums too.
- That's it. That's the diet. Any meat will do, including offal, though once or twice a week only (tripe is extremely good for dogs, especially green tripe if you can stand the smell. I can't).

- I prefer to chop stuff up, but some people feed their dogs whole raw chicken wings or backs (bone included).
- Fish is also fine, the oilier the better, and including canned sardines and pilchards, which is handy when you're travelling.

You can start adding other ingredients too: little scraps of cheese, a tablespoon of live yoghurt, a raw egg twice a week, fruit, if that's what you have (but not grapes or avocados), a tablespoon of a nutritious oil. If you can't be bothered to mix this up every day – though it takes seconds in a food processor – freeze it, bag it and thaw a batch as required.

Needless to say, some pet food companies now exist that will do all of the preparation for you, using high-quality ingredients, telling you where their fit-for-humans meat is from, packaging it up, freezing it and delivering it to your door. There's a brand called Nature's Menu that's available in many pet stores (naturesmenu.co.uk); a brand called Honey's Real Dog Food that will make individual foods for individual dogs, taking in breed, age and so on (honeysrealdogfood.com), and which uses wild and organic meats as standard; a brand called Laverstoke Park that is also organic (and available from Ocado); and my own introduction to the genre, Nutriment

(nutriment.co). Nutriment encourages you to visit its factory, which is, er, not an idea most dog food manufacturers would go a bundle on, to put it mildly. A new company called Cotswold Raw looks promising too. All of these brands include ground bone in their food, for the minerals contained therein. You still need to provide raw meaty bones on the side.

See how you get on. Some people don't quite trust themselves to DIY, and like the reassurance of buying the food ready-made, with everything in the right proportions – Nutriment, among others, adds things like coconut oil and spirulina. The ready-made foods might also be easier to take if you're squeamish, don't live near a butcher or are vegetarian. (Please respect nature and don't have a vegetarian dog. It's so selfish and disrespectful – done only to please you, with zero regard for the dog's biological needs.)

There are a couple more points to bear in mind. First, either feed raw or don't. A combination of raw feeding and dry feeding – for example, kibble – is not helpful, because these foods are digested in a completely different way and all you end up doing is badly confusing your dog's stomach. Second, if your dog is from a breed that is prone to kidney stones, you need to follow a raw diet that is free from organ meat and high-purine vegetables. The companies I have named here can all provide advice

(even if you don't buy their products) and some, notably Honey's, can also mix up the appropriate food if you don't fancy doing it yourself (see their website).

When I have to feed my dog food that isn't raw, because we've just arrived somewhere at 10 p.m. and all the shops are shut, for example, I feed him canned Lily's Kitchen (lilyskitchen.co.uk) – we keep a stash in the car. This isn't because I admire the pretty labels or feel reassured by the relative expense compared to a can of Britain's most popular tinned dog food (absolutely rank), but rather because I admire the can's very high-quality contents.

PUPPIES AND RAW FEEDING

- Start with lightly cooked meat and veg, whizzed in a blender. Chicken is a good place to begin. No bones yet. Alternatively, buy a ready-made puppy preparation. Either way, feed small meals three or four times a day.
- From twelve weeks, slowly introduce the adult (fully raw) diet and feed twice a day.

If you think all of this sounds a bit nuts – and some people do: I may even have been one of them at some point – then by all means feed your dog traditional dog food. I would personally recommend canned or foiled food over kibble, for the reasons I have explained above (biscuits aren't a food, to précis), and I would still very much recommend supplementing these cans/foils with raw meaty bones, for both dental hygiene and mental stimulation purposes. Also, do read the ingredients list carefully, and make your choice accordingly.

Chapter Six

THIS CHARMING DOG

In dogs as with humans, manners are everything. Imagine the best-looking man in the world – *so* handsome and dashing – coming into your house for dinner. Imagine him racing into the entrance hall, leaping about all over your furniture, jumping up at your small child and knocking her to the ground, nicking half the dinner from the kitchen worktop and then doing three small wees on the carpet – all before he'd even said hello. This would not be OK. It would not be OK if he then spent the rest of the evening making weird, aggressive noises, or emitting high-pitched whines. It would not be OK if he bared his teeth and growled if you ask him to get his muddy feet off the sofa. You would not forgive him purely because he had a really appealing face and lovely soft hair. It is not OK in dogs either.

Now imagine that same man coming into the house, saying hello nicely, pottering about for a bit to check out the décor before coming back, graciously accepting your offer of a drink and curling up comfortably on the rug, where he stays quietly for the duration of his visit, charming even the guests who weren't at all sure about you asking him round in the first place. (I do realize that my analogy isn't entirely persuasive. Who is this man? Why is he curling up silently? Why does he lap water like that? WHO IS HE?)

The point is, you must teach your dog manners — manners that make him a pleasure to live with, and manners that make him a pleasure to go into the outside world with. Again, it's rather as with a child: no one likes the kid who bites, or freaks out because the chips are straight and he wanted CURLY, or won't go to bed. Most of all, nobody likes the child whose parents never tell him off.

Your dog has not gone to finishing school, or even nursery school. He needs to be taught a whole load of behaviours, because he is an animal. He has absolutely no sense of what does or doesn't constitute good behaviour. It's all up to you. You are the school.

I dislike – yes, actively dislike – people who don't like dogs. I think there is something the matter with their souls. There's something odd, to me, about not liking, or

even just appreciating, a creature that is wild and free and full of spirit and joy. But I do understand that some people dislike dogs because they are scared of them, and that sometimes (though this is actually quite rare) they are scared of them because they have had a bad experience. As a dog owner, it is your responsibility to set these people straight, to reassure them that your dog isn't like the dog who frightened them or made them feel anxious in the past. Your dog is not like the other dog they know – the one that comes round and pisses on the carpet, or the dog that drools everywhere, or the dog that smells bad. Think of yourself as being on a one-person crusade to convert the dog haters. That means teaching your dog manners.

Dog Haters

Some people are just really scared of dogs for no reason. They weren't bitten as a child, they weren't chased by a pack of hounds, pressed up against a wall by their slavering jaws and saved from certain dismemberment only by the timely arrival of a brisk woman with a whistle. Their great-auntie's poodle didn't do a really traumatizing, freaky shit on their pillow at bedtime when they were little. They were probably brought up in animal-less

households and remain disconcerted, or even disgusted, by the idea that you'd choose to live with – let alone passionately love – a non-human creature.

This is their loss, really, but the unthinking ease – the pride, almost – with which they articulate their fear and distaste is quite wearying. There are currently more dogs in the UK than at any time previously – they recently overtook cats in popularity as pets – and the dog haters need to get with the programme a little bit. Not least because a person who says, 'I'm coming round at 6 p.m. Could you put the dog away?' never realizes that, to the dog owner, this translates as, 'I hate the thing you love,' and can trigger a most terrible attack of internal rage – 'I'd rather fricking put *you* away, mate. I don't even like you,' etc.

The thing that most upsets me about dog haters is that they pass their dog hating on to their children. Children and dogs are natural companions – natural *friends* and allies. It's an amazing bond to witness. When my daughter came home from hospital following surgery, Brodie – who was pretty boisterous and only one year old, and whose relationship with her had until then centred around them both bounding and being giddy – licked her gently, followed her to the sofa where she would recuperate, lay alongside her like a rug and guarded her for two weeks. Not a leap, not a bound, not a jump.

He was about as giddy as Gordon Brown on a Sunday morning. He only left her side to eat or go for a walk.

Three years on, they remain joined at the hip. My adult children quite like coming to visit us, but are shouting, 'Brodie! Come here, Brodie!' before they've even stepped through the door: I'm in no doubt that he's the main attraction. The idea that any child would miss out on this incredible, almost telepathic closeness with an animal makes me feel sad. For many children, a pet animal is their only remaining connection with the natural world. The idea that any parent would encourage them to miss out, by broadcasting their own dog fears and prejudices to their kids, makes me annoyed. The toddler that starts screaming because it meets a dog at the park does my head in. While I'm at it: who are these people in parks who scream with fear at people walking their dogs? It's a park. One of them once screamed, 'Control your dog!' at me, while clutching her two hysterical children to her side. My dog was inspecting a crisp packet. He wasn't even *moving*.

We are all responsible for teaching our dogs manners, and I am of the strong opinion that owners who don't bother to do this shouldn't be allowed to have dogs in the first place. But some people need to learn manners too. All dog owners hate children who scream at blameless

dogs, for example. We find them pathetic and wet, and we blame their parents – because it's certainly not the children who got themselves this way. If you have encouraged your child to be the kind of child who starts yelling in terror when a dog strolls past them, minding his own business, sort it out. It doesn't make for happy human–dog relations, and it's your fault.

While I'm on children, it is crucially important to teach children – all children, whether you have a dog or not – that dogs are not toys but that they *are* friends. This is as important as, for example, teaching children to swim. There are particular sorts of adults who don't really know how to handle themselves around animals – usually people who didn't themselves have pets as children – and, to be absolutely brutally frank, those people strike the rest of us as drippy in the extreme, to the point of sometimes wanting to laugh. It's fine not to like dogs, but to seem slightly scared of a tiny dog that's basically a human teddy – well. It happens. And one does not entirely know where to look.

So, two-pronged approach, with children. One: we respect dogs. We do not pull their tail, or poke them in the eyes, or pick them up and carry them about, or try to ride them. We do not chase them unless we want to be chased back (we will absolutely 100 per cent not like being chased back). We politely say hello to dogs. We ask

their owner if we may pat them. We are gentle with them. If they want to play with us, great. If they don't, never mind. We never force them to play with us. We talk to them in a calm voice.

I know several dogs who don't like children because visiting children frightened and alarmed them when they were puppies. The children's owners never intervened. They just stood around thinking it was funny and saying vague things like, 'Orlando, darling, don't poke that poor dog with the pen.'

Two: children need parents who teach them to think, 'Dogs are potential friends. We do not have to be scared of them. They will only bite us if we have made them frightened or upset. Hurrah! A dog! Let's ask their human if we can pat him, and we'll take it from there.'

I am absolutely aware that there are horrible, irresponsible dog owners out there. There are also nice ones who don't know how to control their dogs, which is a whole other can of worms: those people need to get to dog school (see page 155) and stay there until they are able to take their animal out in public. The person who shouts, 'Sorry, sorry,' while ineffectually calling their dog as he's rushing towards you, teeth out, has no place being outside – and not much place owning a dog either.

*

The good news about all of this manners stuff is that your dog is a genius. He is super-eager to learn, and he learns very quickly. More, he is *interested* in learning, because he is a marvellous dog who likes feeding his brain almost as much as he likes feeding his stomach, and who only wants to please you so that you love him. The happier you are with him, the happier he is with and in himself. Note that this willingness to learn does not vanish with age: it's at its greatest in a young dog, but you can absolutely still teach an old dog new tricks. Never think that you've left it too late.

Here's how to have a charming dog.

Socializing Your Very Small Puppy

Once your puppy is home and is getting used to the gist of everyday life in your house, and seeming secure and confident in his new environment, it is time to take him outside. Now, you can't do this in the normal way – by putting on a collar and lead and venturing on to the pavement – because the puppy isn't allowed to do that, or to play with other dogs, until his last batch of vaccinations have fully kicked in – some weeks away. Until then, you must carry the puppy and show him interesting things. Put a small, soft collar and lead on him anyway, in case of wriggling, and away you go.

Take the puppy to as many places as possible, carrying him in your arms and sitting him on your lap. Take him to cafés and pubs. Take him in the car. Take him on the bus. Show him fire engines and bicycles and rowdy groups of boys and tramps sitting on benches. Show him the insides of shops, and toddlers and gaggles of children coming home from school. Show him short buildings and tall buildings, empty spaces and ones that are packed tight. Show him cars, motorbikes, delivery vans and bicycles, or tractors, combines and horseboxes, depending on where you live. Show him people of all shapes and sizes, and of all ages and colours. This is more important

than you'd think: puppies who have never met, say, black people or very old people can seem racist or ageist, which obviously is mortifying and not what anybody wants. If nice-seeming people are keen to stroke the puppy, let them: you want a puppy who doesn't growl at benign strangers.

The earlier you introduce your puppy to as wide a slice of the outside world as possible, the more relaxed and confident he will be. He may not *like* all of the things he sees – you're there to comfort him whenever that's the case – but he will take them all on board and store them away for future reference. Be mindful that everything is monumentally vast to a puppy and that he will be fearful of lots of things initially. For example:

- People of all ages and all hair colours
- People who are fat and people who are thin
- People in wheelchairs/using walking sticks/with Zimmers
- Buggies
- Skateboards (blew Brodie's mind)
- Motorbikes and mopeds
- Loud, shouty people
- Silent, shy people
- Runners and exercisers
- People with hats or helmets

- People with sunglasses (and normal glasses)
- People with facial hair
- Babies
- Toddlers
- Young children
- Teenagers
- Dogs
- Cats
- Other pets
- Livestock
- Ducks
- Horses
- Pubs
- Fairs/country fairs
- Bodies of water
- Sea/beaches
- Parties
- Traffic

Taking Your Puppy for His First Real Walk

The day has come: the puppy's vaccinations are complete and the vet says it's OK to take him out. Monumentally exciting times, obviously – but perhaps more exciting for you than for the puppy. The puppy has never been

on a walk before. He doesn't really know what to do, or how to behave, and everything will seem overwhelming to him. He is small and vulnerable and doesn't know what's going on. Try and ensure that he enjoys the experience. Watch him like a hawk – not difficult, as he will constantly be looking at you for reassurance and guidance. Watch his posture. Is he trying to make himself smaller? Is he cringing? Is he chipper? If the sight of something is clearly making him miserable, comfort him. Keep these first walks short and sweet. It's a good idea to stash a delicious treat between the ring and middle finger of the hand that's closest to the puppy. He will follow the delicious smell and stay close to you in a manageable way.

Discourage him from pulling on the lead and half-strangling himself (see page 166).

Very important: if your puppy is scared or overwhelmed, he will stop walking. He will lie down and refuse to budge. He isn't doing this to be a pain: he is doing it to show you that he is frightened. Do not, for heaven's sake, drag your reluctant, scared puppy along by the lead, or shout at him, or tell him off. Pick him up for a bit, carry on walking with him in your arms, and put him down again a little while later. Keep talking reassuringly to him in a calm voice. If he trots along happily, praise him lavishly. Also, put yourself in his shoes (paws):

he's a little puppy. The great big outside world is amazing, but also deeply intimidating.

Remember my hypothetical man at the beginning of this chapter, who jumped about everywhere and knocked things over and stole the dinner? Ask yourself how you would have handled him. Your aim is to teach him, through a combination of education and persuasion, that behaving like this is not acceptable, and that it makes you sad. How are you going to do it? Would you rub the man's face in his own wee? Hit him in the eyes? Slap him? Would you then sit back in a satisfied way and say, 'I'll keep doing it until he learns'? Do you think that would work? Do these methods make you feel, I don't know, uncomfortable in any way?

Until relatively recently, it was considered perfectly acceptable to do all of these things to 'misbehaving' 'naughty' dogs. I've substituted 'eyes' for 'nose' because they'd be our human equivalent: dogs' vision is nowhere near as good as ours, but their noses are super-noses – scent is their dominant skill. The scent-detecting area inside their noses is fourteen times larger than ours. The bit of their brain that processes scent is commensurately larger too. Puppies detect you by scent long before they detect you by sight. Their noses are their superpower. I don't think anyone should tap or slap or

hit anyone on the superpower to 'teach them a lesson', or smear the superpower with urine. Aside from anything else, it doesn't work. Making your dog frightened and anxious, or hurting him, will probably result in him stopping the undesirable behaviour: if you slapped me round the head every time I made a cup of tea, I'd stop making cups of tea. But only because you hit me when I did.

This is abuse, really. It's not a learning experience. What am I being taught, other than to be scared of you? Crucially, when am I supposed to be *not* scared of you? I have no idea. You hit me for making tea – who's to say you won't hit me when I open the fridge? Oh look, you just have. Just a tap, was it? Doesn't feel like it. Now I'm scared of you, because you make no sense: you hit me for some things, but not for others. You cuddle me and tell me you love me, but now you're hitting me again. I'm on eggshells around you. I'm so happy when you are kind to me – I'm the happiest creature in the world. But sometimes I pee with fear when you start to raise your voice. Tell you what: I'll try and do everything you want. It means I will be on tenterhooks all the time, living in a perpetual state of anxiety, incomprehension and fear. I'll be sad for at least half the day. In time, I'll develop serious behavioural issues. But – hey, at least I won't make cups of tea any more. Or do anything else that displeases

you. Whatever those things might be. God knows, because I certainly don't.

I don't like it when you hit me, by the way. I feel angry. I don't trust you. There is a part of me that feels threatened by you. When I'm threatened, I can suddenly become aggressive. Who knows how *that* might end. Did I mention that I'm armed? I could take your face off, actually. So there's that.

Unacceptable, right? Downright horrible. Abusive. But not for dogs, apparently.

I'm wary of writing this, because I am well aware that thousands of people still use discredited punishment-based methods from the 1970s to train their dogs, and that those 1970s methods themselves come from dubious dog-training tactics stretching back many decades, to Colonel Konrad Most, whose *Training Dogs: A Manual* was published in Germany in 1910 and translated into English in 1944 (it's still in print, which tells you something).

Colonel Most, who may or may not have been impressive in the trouser department, believed that man could only reach dominance over dog by physical force. People *flocked* to his book. Variants on the theme trickled, and then flooded, down through the decades. These days, thank God, no competent dog trainer in Britain advocates the use of punishment or dominance any more.

Neither does the Kennel Club. Neither do any of the dozens of breed clubs. Neither do breeders. Neither do vets. Neither do dog charities. They are all now vehemently against you ever laying a finger on your dog. That, hopefully, tells you something. I'm hardly a lone voice in the wilderness here – reward-based, as opposed to punishment-based, methods are the modern norm. But you wouldn't necessarily know it from the conversations I've had with people, mostly but not exclusively older, who feel very upset when you express dismay at their twentieth-century 'hit him on the nose', 'rub his face in it' ways. They always, always say the same thing: 'But look at how much my dogs love me. I'm brilliant with dogs. I've had six. They're all lovely, happy dogs.' And that may be perfectly true. But the reason for it isn't the human's great skill at dog rearing. It isn't to do with the effectiveness of punishment. The reason they're 'lovely' dogs is the dog's infinite, pathetic desire for love. It is the dog's unbearably sad longing for kindness – even if the kindness is all tangled up with things, like punishments, that the dog doesn't understand or like. It is why, at the very extreme end of that particular scale, dogs still love the people who abuse them so horribly that they end up in jail. For a dog, any love is better than no love, and any owner is better than no owner. It is completely heartbreaking.

Why have these punishment-based methods become so discredited? Has everyone just become too wet and weedy for good, honest, no-nonsense dog training? Is it dog political correctness gorn mad? Not at all. It's to do with knowledge and science: academic advances in canine biology and psychology – advances in learning how dogs function, how they think and what makes them tick. Just as no sane person would raise their child according to a blueprint dating back to 1910, so no modern dog owner thinks it's a good idea for their dog to be frightened into submission using variants on the methods laid out by Colonel Most.

By the way, as I've said earlier, I don't have any truck with the whole 'alpha' business either. This – a satellite of the punishment way of doing things – is another chronically old-fashioned theory that centres around the belief that your dog wants to be the boss of you and that you absolutely mustn't let him.

The dog, the thinking goes, is a pack animal, and the pack animal has a leader, an alpha. It's either him or you, so you'd better show him that it's going to be you, by force if necessary. This is all very well in theory, except we now know that dogs aren't pack animals, for starters. They are highly *socialized* animals, which isn't remotely the same thing – so socialized that they super-cleverly evolved themselves from wolves into dogs, and in the process

learned to function solo, as part of a human family – *not* a pack.

All of our thinking about dogs' behaviour has been predicated on what we know about the behaviour of grey wolves, with whom our domestic dogs share 99.96 per cent of their DNA. But it turns out that everything we thought about grey wolves was wrong. In his brilliant, eye-opening and important book *In Defence of Dogs: Why Dogs Need Our Understanding* (2011), John Bradshaw, a zoologist who has spent his life studying dogs and who founded the highly regarded Anthrozoology Institute at Bristol University, uses science to show how we've badly misunderstood this crucial stuff. I couldn't recommend this book more strongly, and I could quote it for pages, but you should go and read it for yourself. Here is the gist, though: the wolf pack does not have an 'alpha' leader who fought off all other pretenders to achieve dominance. Wolf packs are sometimes comprised of a gaggle of wolves who come together because they've killed something big and it's too much for just one wolf to eat. 'In summer,' Bradshaw writes, 'when alternative prey is often available, these larger packs tend to fragment into smaller units, perhaps coming back together in the autumn.' They're basically a syndicate – hardly the marauding, alpha-led pack we'd imagined. And besides, those packs aren't even the norm. 'It is now known that

the majority of wolf "packs" are simply family groups,' Bradshaw writes. The leader – the dad – is the leader because he helps the weaker members of the pack – his offspring. He's not constantly watching his back, waiting to be dethroned, needing to stay ferocious and scary and so-called 'alpha'. He's chilled, not vicious. Wolves look after *each other*. The pack leader is not dominant in the way we understand. He facilitates. And he does not facilitate by using fear or intimidation. Unusually, wolves don't boot their offspring out on their ear when they reach a certain age:

> Provided that no one is starving, the cubs may stay with their parents until they are fully grown. Once they are experienced enough, they will participate fully in hunting, and thus a pack emerges. Often the younger members will still be part of the pack when the next litter of cubs is born, and will help their parents to raise their brothers and sisters, bringing food back for them and babysitting them when the other members of the pack are out hunting. *Contrary to many notions of wolf behaviour, co-operation, not dominance, seems to be the essence of the wolf pack* [my italics].

This turns everything we thought we knew about wolf, and by extension dog, behaviour on its head. 'Packs

that form naturally in the wild are usually harmonious entities, with aggression being the exception rather than the norm,' Bradshaw writes. And yet, 'The image of a harmonious pack is not the picture of wolf society that you will find in most books on dog behaviour.'

How did we get it so monumentally wrong? In brief – do read Bradshaw's book: for a dog lover, it's more gripping than most novels – it happened because scientists studied captive wolves, not wild ones: groups 'basically composed of whatever individuals were available for the zoo to make an exhibit'. The packs these captive wolves formed were totally random – they were forced together because they were captive, not because they chose to come together. As a result, 'the relationships that emerged were based not on long-established trust, but on rivalry and aggression'. Isn't it fascinating? We only know what we know about the true behaviour of grey wolves in the wild because of technology: better tracking devices came into being, as did

GPS, miniature radio transmitters with batteries robust enough to allow tracking over a whole season, and so on. Within a decade, descriptions of wolf society had changed from the image of the hierarchical pack run by two tyrants, one male, one female, to that of the harmonious family group, where, barring accidents, the younger

adults in the family voluntarily assisted their parents in raising their younger brothers and sisters. *Coercion was replaced by co-operation as the underlying principle* [my italics again].

Bam: and there you have it. (Bradshaw goes on to explain how 'submissive' behaviour is nothing of the sort, by the way: another desperate misinterpretation of the facts based on observing captive animals rather than ones in the wild.)
He asks:

Which of these two models points to the most appropriate way to understand pet dogs and their relationships with their owners? Is it the 'alpha' model, based on the unnatural captive pack, or the 'family' model, based upon the behaviour of wolves that have been allowed to make their own choices as to who or who not to live with? The family model is the product of millions of years of evolution [. . .] The alpha model emerges only in artificial social groupings that evolution has never had the opportunity to act upon, and in which individual wolves have to draw upon every ounce of their intelligence and adaptability just in order to survive the relentless social tensions inherent in such groupings.

It is as though a Martian had picked random humans, imprisoned them in a house together and concluded that their behaviours were typical of all humankind. 'Scientists,' Bradshaw concludes, 'have (inadvertently, to be fair) studied the wrong wolves, on the wrong continent, and 10,000 years too late.'

So. Tell that to the occasional hideous thicko owner who feels like a big macho man for wrestling his dog and 'showing him who's boss' before opening the beers and shouting at his wife. Ugh. The man is a throwback, and so is the thinking. It's still prevalent, though, because even the information contained in internationally best-selling books like Bradshaw's doesn't trickle down far enough. Not that many people have got the message. Some of the nicest, kindest, most dog-loving owners still absolutely believe the alpha stuff, even though it has been completely discredited. We're still stuck in the period of Barbara Woodhouse, the Mary Whitehouse of dog trainers. Cesar Millan, America's best-known and most successful dog trainer – dozens of chart-topping books, TV shows, magazines, and even his own Cesar Millan Foundation – has written: 'Dogs have an ingrained pack mentality. If you're not asserting leadership over your dog, your dog will try to compensate by showing dominant or unstable behaviour.' Every word of this sentence is bullshit. (In a video, which came to the

attention of Alan Titchmarsh, Millan is shown punching a dog in the throat. Titchmarch called his methods 'cruel' and 'unnecessary'. Millan said the punch was just a 'touch'. Hm.)

I'm glad I've got that off my chest, where it has weighed very heavily for some years. Knowing what we know, why on earth would we still want to dominate or frighten dogs?* But away from this deep unpleasantness and onwards, to charming dogs. With charming, well-informed owners, who know that the best way of show-ing love is by being kind.

'WE HAD DOGS WHEN I WAS A CHILD, ACTUALLY'

You will almost certainly have friends who once had a dog forty years ago, or when they were little, and who therefore consider themselves to be excellent, up-to-speed dog people. Which they no doubt are. The problem is

* Because we're a big, frightened loser with a micropenis, I would angrily posit.

that their understanding of how you get a dog to behave dates back to this period. If your dog does something that someone like this disapproves of, they will feel no qualms whatsoever about 'telling your dog off', using methods their own mother or father used to great effect in 1975. If this involves laying a single finger on the dog – 'just a tap' – it is perfectly fine to say, 'Would you mind not doing that, please?' They'll be utterly puzzled – but they're so good with dogs! What on earth is the matter with you? You can explain, or not explain, but do get them to desist at once. You don't go around tapping their children. There's absolutely no reason why they should tap your dog, or rub your puppy's nose in his own urine, or use any of the other nasty, discredited methods. Needless to say, these methods will completely freak your dog out if he is only used to people being kind.

The opposite of punishment is reward and the opposite of confusion is understanding. We don't want confused, scared dogs – we want well-behaved ones, and if we want them to be happy, rewards-based teaching methods are the best option to help them understand why certain behaviours are preferable to others. Also, rewards-based

methods work. One of their inventors was Dr Ian Dunbar, a vet and dog trainer for twenty-five years, who based his techniques on dog psychology, backed by a doctorate in animal behaviour from Berkeley and a decade of research on communication and behaviour in pet dogs.

Now, this isn't a dog-training manual. I'm going to share a few simple techniques and tricks that I have found particularly useful, but if you want whole chapters of this, then I suggest you rootle about online – there's a lot of free information – or invest in a dog-training manual from your local bookshop. Having said that, once you've mastered teaching a few basics, you can probably carry on from there by yourself: the principle doesn't alter. If you have a new puppy, I strongly suggest that you enrol in puppy school – usually a two-hour lesson once a week, for dogs and their owners – to boost your own confidence as a new owner, but also to see amazing dog whisperers at work. Good dog trainers are incredible people. They are incredible to dogs before they've even moved or opened their mouths: one of the things I enjoyed about Brodie's puppy-training classes was the way the puppies all *loved* the trainers. They (the puppies) would rush up to them (the trainers) as if they were Matildas meeting their Miss Honeys, and sit at their feet gazing adoringly before the lesson had even started. If you do go to school, then please make sure that the

trainers are not using old, cruel, discredited methods from the last century. Call them and ask: their methods should be exclusively rewards-based. Any talk of choke or electric collars, alpha rolls, lead jerking, spraying water and so on should see you put the phone down sharpish.

Please note: dog schools are brilliant but they are not a magic bullet. They won't train your dog *for* you. *With* you, yes. It takes patience, time and commitment.

Guidelines on Training

- Keep training sessions short. That way nobody gets bored. Short sessions are much more effective.
- Show your dog what you want him to do, never make him. Never physically put him in one position or place (e.g. pressing down on his bottom to make him sit).
- Be absolutely consistent. Don't change the phrases you use.
- Be armed with treats. We used bits of dried liver and bits of Cheddar cheese. If you're giving a lot of treats, feed your dog slightly less at mealtimes.
- Most treats are freakishly huge. Break off tiny baby's-fingernail-sized bits and give those. You

don't want your dog to be so stuffed full of treats
that he loses interest, and nor do you want him to
get (puppy) fat.

- Important: have some normal treats and some
 high-value treats – that is, treats that are more
 special (delicious) than the normal treats. These
 high-value treats are to be deployed either a) when
 you want to teach your dog something quite
 challenging and counter-intuitive, like not chasing
 rabbits, and need the most irresistible and
 persuasive (and stinky, probably) backup you can
 get; or b) to reward him when he's managed
 something you've been working on for ages –
 coming back to you in a fascinatingly crowded
 place, for instance.
- Always praise your dog as you give him his treat-
 reward. Say 'Good dog' or 'Good Peabody' or
 whatever. Treat + praise = double positive.

What you're trying to do, with training, is to teach
your dog good manners. The more you praise and reward
these manners, the more eager your dog will be to show
them off. In time, he will just do them automatically – no
treat required other than a pat (which is, to a dog, a very
great treat indeed, though not as mind-blowingly amaz-
ing as a cuddle).

For example, our dog is a Wheaten terrier. Wheaten terriers are exceptionally bouncy. They jump up whenever they are even a little bit excited – boinggggg. Obviously, not everyone likes this. It is difficult to get a Wheaten not to jump up when he meets somebody new. But it is easy to get him to learn the 'Sit' command with the help of a piece of cheese. Deploy the 'Sit' command whenever he meets someone new, praise and reward, and soon he sits automatically when someone comes through the door.

You get to this point by ignoring bad behaviour. You do not dignify it with any response at all. Remember when I said (see page 99) that if a puppy nips, it's good to turn your back? Same principle. Dogs constantly want your attention and approval. Deprive them of it and they alter their behaviour. That's not enough on its own, of course – turning my back wouldn't stop Brodie jumping up. But turning my back when he jumped, and then asking him to sit when he came round and found me, and immediately rewarding him when he did, worked beautifully.

Some things to bear in mind:

🐾 **Repetition is the key to training** Don't try and cram loads of training into one day – you'll both get bored and disheartened. Little and often works best. Keep sessions to ten minutes, max, even if

you're both still having fun. Puppies find training exhausting and will go for a nap afterwards.

🐾 **Teach one command at a time** . . . and don't move on to the next one until your dog has got it nailed.

🐾 **Always keep eye contact** Eye contact is crucial. Don't wear sunglasses!

🐾 **Don't be cross if your dog takes a while to learn the command** It's like riding a bicycle: it might take a while to master, but once you've got it, you've got it for life.

🐾 **Be patient** If you're not feeling patient, don't have a training session.

🐾 **Don't train your dog if he's hungry or tired**

🐾 **Make sure that everyone in your family uses the same commands** Children often want to make up their own ones. Don't let them.

🐾 **You can supplement the verbal command with a visual signal** . . . displaying your open palm to signify 'Come here', for instance. It makes things easier for some dogs, plus it works better in a crowded place.

🐾 **Have realistic expectations** Don't expect any of this stuff to happen overnight. But training your dog is interesting and fun, so that's OK.

🐾 **Try to end the session on a high** . . . with something you have praised and rewarded for.

🐾 **Remember to always praise the dog as well as giving him the treat** Double whammy.

Five Basic Commands

Sit

1. Stand in front of your dog with something delicious in your hand – let's stick with a tiny bit of Cheddar, because it's what worked for me, but any treat will do. Show him the Cheddar. Close your hand, with the Cheddar in it. Yum, thinks the dog. Cheddar. Mmmm. I want to eat it right now. I love that cheese.

2. Move your hand away from his head towards his tail, saying, 'Sit.' His head will go up towards the Cheddar, which means his bottom will automatically lower. If it doesn't, keep trying – it will take a few goes, but eventually he will sit without even knowing that this is called sitting. Praise him lavishly, give him the Cheddar, repeat. He will learn to associate the word 'sit' with, well, sitting, and he will know that he is rewarded when he sits. That's how you teach SIT.

Down

1. Cheddar in the hand again. Show it to the dog. Close your hand. Ask your dog to 'Sit'.
2. Gradually lower your delicious Cheddar-containing hand towards the floor and

clearly say, 'Down.' His head will follow your hand, which is now at ground level, and he will lower.

3. Give him the Cheddar and praise him. Repeat. That's how you teach DOWN. Again, it will take a few goes. Keep practising over the days so that it becomes second nature.

Stay

1. Cheddar, hand, show hand and Cheddar. Ask him to SIT or lie DOWN.
2. Move back one step while saying, 'Stay.' Count to three in your head.

3. Step back towards him, give him the Cheddar, praise him. Repeat. Keep saying, 'Stay,' when you want him to stay.

4. Over time, increase the number of steps back that you are taking. Give it time – if you suddenly disappear round the corner, he'll just come looking for you, which is fair enough. Go two, then four, then six steps back, and so on. If he stays at four steps and not at six, go back a step (literally).

Come here

1. Be milling about doing something else in the same room as your dog. Get a delicious treat. Show him the treat and say, 'Come here.' The

dog will come. Give him the treat and praise him. Say something like, 'Off you go,' to indicate that he is free to potter off.

2. After you've done that a few times, randomly go out into the hallway at some point in the day. Same thing: 'Come here', treat, praise, say, 'Off you go.'

3. Carry on over a few days: go into the kitchen, upstairs, downstairs, into different rooms – but randomly, when your dog isn't expecting a game or a treat. Say, 'Come here.' Give treat and praise. Say, 'Off you go.'

4. Once he finds you every time, wherever you are and regardless of whatever other exciting thing is happening in the house, and once he comes immediately, as soon as you've called him, go and buy a long line. This is a hugely long, er, line of sturdy rope or fabric – like a ridiculously long dog lead, basically, that you attach to your dog's collar for certain training purposes.

5. Now take your dog to a public place where there are distractions. Affix the long line and go for a walk. Then stop and let him potter about and sniff, talk to other dogs, explore. Let him go right to the end of the long line. When you are ready, and at a relatively unbusy time for him (i.e. not

when he's surrounded by new friends or fascinated by a new thing), say, 'Come here.' Do not pull the line to tug him towards you. When he appears, no matter how long he's dawdled, praise him and give him his treat. Then say, 'Off you go,' or whatever phrase you've chosen. Carry on with your walk, otherwise he will think COME HERE means that the lovely walk has ended. Try out the command several more times.

6. Do this over several days, until it's absolutely perfected, and then, and only then – gulp – try it with the dog off the lead altogether. Do this somewhere quiet and relatively unpopulated: if the first thing he sees is a gaggle of dogs he wants to play with, he's not going to be able to concentrate properly. Don't forget to keep giving the treats. You can ease up on them – give half the original amount, say – when it's all working like clockwork (and see below on how to phase them out).

Heel

Or: how to teach your dog to walk nicely on the lead without getting all tangled up and tripping you over,

or without him pulling so hard that he's getting strangled.

1. Decide whether you want your dog to walk on your left or your right. We're going to teach him to stick to it, so decide and don't change your mind.
2. Hold the lead loosely in the opposite hand.
3. Put a treat in the hand closest to your dog. Show him it.
4. Start walking.
5. He should – again, it may take time – follow the treat-containing hand. If he does, give him a piece of the treat.

6. Keep the rest of the treat in your hand. Carry on walking. As he trots alongside you, say, 'Heel,' and give him another bit of treat. Keep walking.
7. If this doesn't work – and it does not work the first time – and he's opposite where he's supposed to be, change directions and call him to you. Treat and praise when he is by your side; proceed as above.

This way of training dogs – all carrot, no stick – works for everything. I'll just say it again: a dog will repeat any behaviour that has an enjoyable outcome for him. Attention is an enjoyable outcome. If you start waving your arms and yelling 'no' when he steals food, that's attention. And food too. Bingo! Not a problem for him. But if he steals food and gets no attention, that's a little bit sad. So only reward and praise the actions you like. He will soon learn. Remember, the reward and the praise must come *immediately* after the good action, otherwise it's too late. The dog won't know if you're praising him for not jumping up ten minutes ago, or for the cool vole he nearly caught this morning, or for playing with the children, or for sleeping, or what. Reward quickly! Be quick to praise! Otherwise it makes no sense at all to the dog and teaches him nothing.

As for withdrawing treats, don't do this too soon – it's confusing and can even undo the good work you've achieved. Better to stop slightly too late than slightly too early. Rather, once the dog has learned the various commands and behaviours, reward him randomly. Sometimes a treat, sometimes just praise, sometimes a pat, sometimes a cuddle, sometimes everything, some-times nothing – but the promise of something next time. This keeps him on his toes.

Canine Body Language

It's an imprecise science, as you can imagine, but we do know the following:

- A relaxed dog looks relaxed. No part of him seems tensed or taut. His tail is roughly level with his back and is swinging gaily. His ears are slightly forward and his expression is jolly.
- A frightened or anxious dog may have his tail tucked fully or partially between his legs. His ears may be pulled back. His body may seem tense, or he may be cowering or cringing. He may be panting excessively. He may pace up and down for no obvious reason.
- A dog yawning when he is not tired *may* be a sign

of anxiety, ditto a dog licking his nose or lips when he isn't about to eat. May, I said. Nobody knows for sure.

- The best judge of your dog's body language is you. If you think he looks unhappy or stressed, or indeed quasi-delirious with joy, he probably is.

THE BADNESS OF DOGS

Dogs sometimes do very bad things. They kill chickens. They kill deer. They kill someone's beloved small pet. This is terrible. But it isn't actually to do with the badness of dogs. It's to do with dogs being dogs, and having the instincts characteristic of their particular breed. Generations of careful breeding can't banish genetic traits. I've said it already and I'll just say it again: those traits are bred in the bone. A hunting dog will hunt, and so on and so forth. He may not hunt in your back garden in a town, but take him on holiday to the countryside, show him even the whiff of a rabbit, and . . . the inevitable will

happen. This is not a failure of training, or a failure on the dog's part. It's just him being an animal. You should of course take every preventive measure you can when out and about: if you're ever in any doubt about your dog's potential behaviour in a particular situation, keep him on the lead, especially near livestock. But don't be angry with him, or yourself, if he does something brutal and unphotogenic that you don't approve of. He's a dog. It is deeply unfortunate, but sometimes you can't stop him doing the bad thing.

Remember that a farmer has the legal right to shoot a dog that is bothering his livestock. There is no shortage of marked footpaths in the countryside – it is a very good idea to stick to them and not go off-piste.

If your dog bothers people, by which I mean strangers, when you are out walking, keep him on the lead until you have both been trained! Bothering strangers – or, worse, frightening them – is completely unacceptable.

Chapter Seven

DOGS AND THE WORKING PERSON

What I really want to address here is separation anxiety. Dogs – all breeds – love companionship, which is to say, *your* company. They thrive on it. They far prefer it to the company of any other dog – they prefer it to the company of any other creature on earth, in fact. Dogs are not made to be on their own. They love people. They love *you*.

Some scientists now believe that dogs effectively domesticated themselves. Men feared wolves and have a long history of eradicating them. That sits rather oddly with the idea of those same men then turning round and thinking, 'You know, I think I'll try and turn these wild beasts into pets.' The dogs that became friendly became friendly because they – the dogs – wanted to, one theory goes. As Dr Brian Hare and Vanessa Woods put it in their fascinating book *The Genius of Dogs*, our

domestic dogs exist because of 'survival of the friendliest' ('So, far from a benign human adopting a wolf puppy, it is more likely that a population of wolves adopted us'). In an ideal world, dogs would like to be by our side at all times. Obviously this is problematic, since most of us have jobs to go to.

I don't think enough is made of how important this subject is. It's the root cause of a great deal of dissatisfaction all round: owners who can't seem to get on with their dogs in the way they'd anticipated, and dogs who are depressed, anxious and acting up. (The other root cause of dissatisfaction stems from not training your dog properly and expecting him to do stuff *that you haven't taught him*.)

The first thing to know is that dogs *really* don't like being left. It makes them stressed and anxious, as well as bored and sad. The resultant behaviours are the main cause of people being displeased with their dog, and of people feeling that their dog is bad, naughty or aberrant. It becomes a vicious circle: you go to work and leave the dog home alone; the dog hates it and acts out his anxieties – chewing the house to bits, barking, howling, clawing at doors, soiling the floor, shredding cushions or destroying other possessions. You come home and are angry with the dog for having done all or any of these things. You and the dog are now on pointless

non-speaks – pointless, because the dog doesn't know what he's done wrong. The dog's bafflement is understandable. What did you expect him to do while you were gone – cosy up on the sofa with *War and Peace* and a cup of tea? Watch *Escape to the Country*? The next morning, you leave for work, and the whole miserable cycle starts again. And so it goes on. If you think you have a bad, duff dog, you might even end up taking him for rehoming: dog charities are full of such cases. So it is very important to know that your dog isn't doing anything weird or atypical. Dogs don't like being left. That's all.

We don't know much about dogs' concept of time. It is possible that when you leave, they think you are never coming back, but I personally think dogs are too clever to think this for very long past immediate puppyhood. Still, even thinking it a dozen times can't be very nice. Sadness and misery are so counter-intuitive for dogs. They are absolutely joyous creatures. They express delight with their entire bodies – they smile, they wag, they boing and bounce. They wiggle with joy. When you are playing with them, their oxytocin levels quintuple and their endorphins and dopamine levels double – these all being hormones associated with contentment and happiness.

We go out of our way to bond with our dogs, and we usually succeed in binding them tightly to us. They are 'man's best friend'. They are the true loves of our lives.

They are bona fide (or fido) members of the family. We feel, whether science backs this up or not – and it does, to a point – that they give us unconditional love, that they are our friend, that they never judge us, that they are true and faithful and constant companions. This is all pretty intense stuff. I mean, it's a love affair. Dog–human relationships are ardent and passionate, and that's the way we – humans – like it and have engineered it to be. Dogs like it too. They are at their happiest loving us intensely, and being intensely loved by us.

The problem is that you can't turn intensity on and off like a tap. Or perhaps you can – but your dog certainly can't. If he loves you passionately, he will miss you passionately when you are absent. If he is dependent on you for his happiness, it follows that he will feel bereft, lost

and deeply miserable when you are not there. When you leave in the morning, the dog will feel grimly anxious, and that anxiety will remain – and even grow – until you come home. It really helps to see this clearly from the outset. It saves you from feeling cross with a dog for basically loving you so much that he can't hack it when you leave. Some dogs, by the way, respond so badly to separation that they will start pacing up and down, like disturbed animals in a zoo. It's a particularly horrible one because, since it does not involve destruction, you won't know.

Unless you have a webcam installed in your house, you don't see any of this, because you're out at work. You just see the mess when you come home, and you feel cross and annoyed. (A 2015 television programme did just this – it placed webcams in the homes of owners who felt their dogs were problematic. Most of the owners were reduced to tears when they saw their dogs' distress as the day progressed. They were all horrified and had had no idea that this happened on a daily basis. They just thought their dogs were naughty.) And if your dog expresses his distress by barking or howling rather than by being destructive, you may not even know about it unless you have close neighbours who complain.

In addition to all of this, dogs have never been as depressed or more medicated than they are now. A

2015 study carried out by Swiss vets showed that a record number of dogs were suffering from anxiety attacks and depression. Many were prescribed medication. Some of the dogs also suffered from chronic fatigue syndrome, due to the 24/7 lifestyle of their owners. Dog Prozac, which is called Reconcile, was approved for use in the UK in 2010. The horrible thing about all of this is that, as animal behaviourist Tamara Cartwright-Loebl told the *Guardian* in June 2015, 'Many dogs are simply depressed for their whole lives because they're deprived of the normal amount of attention, exercise and stimulation they need from day one. These humans [their owners] won't know they have a problem and won't want the dog any livelier, as that wouldn't fit in with their lifestyle.'

It is all profoundly shocking. In the same article Penel Malby, a dog behaviourist, said:

If you think back even just 50 years, dogs were allowed to roam free every day, socialise with their neighbourhood friends. Now they either go out with a dog walker or go out for an hour if they're lucky, and the rest of the time is spent at home [. . .] You can't get a working-strain gundog if you live in central London and expect it to be OK with a 30-minute trot around the park. Get the dog that fits your lifestyle, and be prepared to change

your life as well. Dogs are emotional beings and need you too.

Back to Cartwright-Loebl:

> Boredom is a big issue and a lack of company and also a lack of consistency and boundaries, and the fiddly-faddly ways of people. One daycare client came to me straight from America, complete with his Xanax. To be honest, I think I needed to take it when I saw it. It was a huge semi-wild working dog that she was treating as a baby – he had pyjamas and a special song.

I can't say it enough: get the right breed and make the right commitment. Don't just 'get a dog' and expect not to change your lifestyle.

Now, having got the doom and gloom out of the way: not all dogs experience intense distress, or at least some dogs experience less distress than others. Unfortunately it's a question of temperament rather than of breed, so I can't say X breed is better at being left than Y breed – it's more a case of Coco being breezier than Kermit at the idea of being home alone. But what I *can* say is that there are things you can do to make all of this separation business much easier for both you and your dog to handle. This sad situation, which affects millions of

dogs every day (an estimated 60 per cent of pets are left home alone), is broadly preventable. It is certainly manageable.

AGGRESSION

You don't need me to point out that a dog who is left chained up in a kennel all day, and barely played with or exercised, or mistreated in any other way, is highly likely to eventually turn his anxiety, boredom and fear into aggression. I'm assuming you're not the sort of person who treats dogs in this way, for which, congratulations. But you don't have to go to those sorts of horrible extremes to make your dog feel anxious or scared, or indeed bored. If he spends all day feeling all of those things, and you come home and are clearly unhappy or irritated with him, he may feel so absolutely confused – by his miserable day and by your unsympathetic reaction to it – that he may conceivably bite. Biting is aggressive, but it is also an expression of fear. Interestingly, it has been noted that it is dogs who are the most anthropomorphized by

their owners – small dogs, usually – who are the greatest biters. John Bradshaw suggests that this is because these owners, intent on, for example, dressing up their dogs in tutus and having tea parties for them, are the worst at interpreting their dog's body language. Hint: your dog's body language is never saying, 'Please put a party hat on my head', 'Please make me more like a baby' or 'I like being ridiculed.'

So: what to do about all of this?

- Don't force your dog to be insanely attached to you – by which I mean, don't raise your dog to be the sort of dog who cries if you go into the next-door room. Not only is this kind of creepy, but it creates all sorts of unnecessary problems. Love your dog purely, as he loves you, but don't constantly pick him up and baby him until he barely knows how to be a dog any more. He's not a dolly. You're not doing him any favours.
- From puppyhood, accustom your dog to being on his own for small periods of time. When he's tired – after an exhausting play session, for instance – encourage him into his crate (take him

to the loo first), shut the crate door and leave the room for three minutes. Ignore any pitiful squeaking. If you've timed it properly, he'll go to sleep – as ever, this may take lots of goes to get right. Just persevere.

- Open the door while he's asleep, so that he can trot out and find you when he wakes up. You can gradually build the time up, but go slowly – he may be perfectly happy with five or ten minutes, but distressed by twelve minutes, in which case stick to ten for a couple of days longer. As usual, reward your dog lavishly – treats and praise – for having survived the appalling ordeal of being without you for *actual moments*.

- Also from puppyhood, shut the door/stair gate when you go into another room. He doesn't need to follow you to the bathroom, fascinating as your ablutions may be. He will very quickly learn that you disappear to a mysterious place for moments at a time, but that you soon come back. Stroke him and praise him when you come back into the room – no need to make a giant fuss, but a loving pat and a 'Good dog' will not go amiss.

- Do both of these things all the time, and encourage other family members to do them too.

The puppy needs to realize that people go off and do things, and then come back, and that it's perfectly fine and unbleak – plus, you get cuddles and treats when they do reappear, both of which are pleasurable.

- If a young puppy is intensely miserable at you being out of sight for (literally) five minutes, do try to butch it out. If he cries and you come back, what he learns is that crying works. Don't leave him to cry for ages, obviously. You're not a monster and I'm not Gina Ford.

- If you do not sleep in the same room as the puppy, he will have learned lots of this already: you go away at night, you come back in the morning and you are both thrilled to see each other.

- Some puppies are simply independently minded, and some are simply not. Adjust your behaviours as required. A more uncertain and gentle puppy will take longer to get used to being left than a more robust, ruffty-tuffty sort, and that's completely fine.

- The first time you physically leave the house, as opposed to the room, make sure you come back quickly. Now is not the time for a three-hour lunch. Go out for fifteen minutes or so, and then gradually add time, in increments of about five–ten

minutes. Keep lavishing praise and dispensing treats on your return.

- Always leave the dog with something interesting to do. Now is the perfect time for a toy that's slightly hard work – a plastic rubber toy with a hollow centre called a Kong containing treats, for instance, or a treat-containing puzzle toy that he needs to work out how to open. Dogs, like people, become destructive when they are bored. Only give this interesting, delicious toy/Kong when you are going out, so that the dog doesn't get overly used to it and looks forward to playing with it each time. Take it off him and put it away when you come home. (Remember to feed less food if you're doling out the old treatoes, to avoid puppy porkitude.)

- Do not rush any of this getting-used-to-being-alone bit, tempting as it may be: the aim of the exercise is to have a dog who is happy to be left for short periods of time, and who isn't going to howl, bark or lose his marbles with the anxiety of it. It's really worth taking time to ensure the happiest outcome for both you and your dog.

- Always give your dog the opportunity to use the loo before you go out.

- Try to go out when he is tired from exercise or play.
- If he associates certain actions with you going out, like the rattle of your keys or the putting on of your coat, and starts looking woe-struck, pat him and give him a treat. You're still going out (boo), but at least something delicious is resulting from it (grudging yay).
- Some people put their dog in a specific room when they go out. I wouldn't, because why confine him to a place (cell) that he will associate with loneliness? What you really want is for the dog to potter about happily in the place(s) where he usually spends his time, whether that's in a particular room, in a nice spacious crate if he is still young, or all over the house if he is a bit older.
- If you come home and find he's gone to the loo/ eaten three wires/knocked over a plant, don't be cross. To be absolutely honest, you should have thought of all of those eventualities before you left. Yes, I do realize what an irritating thing that is to say. True, though. Also, as we have seen at length, crossness and punishment do not work. In this instance, your anger will make the dog

even more stressed and anxious. And dogs
live in the moment. You've been out. He ate
the wire two hours ago. That was then. This is
now. He has literally no idea what you're even
on about.

I never used a webcam to see what Brodie was up to
when we went out. It wouldn't have been a bad idea, and
in fact the RSPCA now recommends that all owners do
it to check for signs of distress (including silent,
non-destructive distress, like trembling or cringing). But
I could tell he was relaxed and happy when we came
home – as time progressed, we would sometimes leave
him for a maximum of two hours, which eventually
occasionally evolved to three hours (very rare). I person-
ally would not leave a dog alone for longer than that, but
that's just my own point of view – I'm going to show
you how to try and make him stay alone for longer in a
minute. In time, he didn't even bother coming to meet
us at the front door – he'd just stay on the sofa and wag
his tail to say hello, and then carry on sleeping. He's a
pretty relaxed dog, but we did take ages painstakingly
getting him used to us not being there. You may find it
harder to train a rescue dog (who is very possibly a rescue
dog because he couldn't hack being left on his own by his

previous owners) – always take advice from the rehoming charity.

This is all very nice, and very In An Ideal World, I do realize. Not everyone works from home, or is retired, or is a stay-at-home parent, or lives in a house where lots of people work/go to school at different times, meaning there's usually somebody about. Most people have jobs to go to, and most offices aren't cool about you bringing your dog to work. Here's how to make an unideal situation work best for everyone.

- Tire your dog out before you leave. Make his morning walk brisk and energetic, rather than dawdly and meandering. Deploy the two-sticks method if time is short – this is the genius invention of my partner (we think). Does what it says: double the sticks, double the exercise, but in half the time. Get two sticks. Throw one stick. Dog chases stick. He runs back to you with stick. Now he wants to play with the stick – he wants to tug and tussle with you over it, which would be fine normally, except you're in a hurry. So. Throw the other stick. The dog will hurtle at full pelt after stick 2, dropping stick 1 at some point in the chase. Pick stick 1 up while he is chasing stick 2, throw it ahead. Repeat. Result: the dog is

constantly running at top speed, pelting after the stick – he is not ambling back towards you with the stick in his mouth or wanting to play tug. This is knackering for him, which is what you want if you're now going to leave him home alone. The two-sticks method is totally great if you want to tire a dog out over a finite period of time. The stick can obviously be a ball or anything else appealing and chuckable if you prefer. Make sure the dog goes to the loo before you take him home.

ARE STICKS SAFE?

There was much hilarity in the early part of 2016, when the president of the British Veterinary Association warned dog owners that their pets could sustain 'terrible injuries' if they played with sticks. He said that throwing sticks was 'potentially life-threatening' and urged owners to use safer dog toys. This was met with incredulity of the political

correctness gorn maaaad sort. 'I've thrown sticks for 35 years without a problem,' Ben Fogle tweeted. 'Have sticks changed?' But vets and charities concurred with the BVA guy: dogs can, and do, get injured by sticks that are at an odd angle on the ground – biting into these means the sticks can impale the dog. Chewing sticks means the dog can swallow splinters, which can lead to infection.

I do see all of this, but I also see common sense. Your dog isn't out picking up sticks on his own: you're right behind him. If a stick looks inappropriate, you can take if off the dog and replace it with a smoother, sturdier stick. As for dogs rushing ahead to impale themselves on sticks that are protruding out of the ground at peculiar angles, they're few and far between. I know it happens, but it's very rare. Still, if you're at all concerned, use a ball or a safe plastic 'stick'. And certainly don't allow your dog to bring a stick home and sit chewing it in his basket, choking on the scratchy shards. There are far more satisfying alternatives.

- A morning walk is non-negotiable: you can't bugger off to work for the whole day without even having walked the dog.
- Provide the dog with home entertainment. Treat dispensers that are designed to be just the right side of frustrating are perfect – they're canine puzzles rather than Rubik's cubes (and they vary in difficulty – start with a simple one). You can also make home-made versions of pass the parcel: get a strongly scented treat, put it in a cardboard box, wrap the cardboard box in newspaper, wrap the newspaper in an old towel, and so on (NB This is not a TIDY game). Also leave the dog with something appropriate and safe to chew.

- Arrange for someone to walk him again later in the day. This can be a friend, a neighbour or a professional dog walker. Your dog will enjoy the human company and interaction as much as the walk itself, plus of course he will enjoy playing with any dogs he meets on his walk. Most dog walkers walk dogs for a good, energetic hour, which means he will be tired when he comes home and will have a sleep. If you can't afford a dog walker, make a suitable arrangement with someone who will do it for free, perhaps in exchange for you offering a skill of your own in return: helping a teenager with homework, showing an older person how to use social media – whatever you can. I don't think it is acceptable to leave a dog alone for ten hours with no human contact and no exercise. I mean, what's the point? Convenient for you, but actively boring and unpleasant for the dog. Get a cat: cats have no difficulty at all in being left alone (I slightly suspect it's their ideal state).
- Doggy day care exists, but I don't know many people who can afford it, and again I would question the wisdom of spending a sizeable proportion of your income on paying someone

else to look after your dog five days a week.
Still, if you have the money, it's obviously far
nicer for the dog than being home alone –
provided that he likes the day-care giver and
that the day-care giver is kind. I'm attaching
that caveat because I used to live somewhere
where doggy day care was a serious business,
and I observed first-hand, when the dogs used
to be taken to the park, that for every fantastic,
dog-fanatic person offering the service, there
were two who were only very nominally going
through the motions, like bored au pairs
smoking fags while their charges dangle
dolefully in swings with no one to push them.
So pick your dog walker/day-care provider with
forensic care. Don't be swayed by persuasive
promises on snazzy websites, for starters.
Observe them at play, with dogs, in your local
park or wherever dog walkers gather, and get
chatting to one that way. Always check out
the premises yourself. Also, word of mouth
remains the best way of getting
recommendations.

- By the way, on the subject of exercise: the walks
aren't purely for leg-stretching purposes. Dogs
need to sniff too. They need to explore and

follow trails and rootle around, and they need
to be completely unbridled and physically free,
in a way that is only possible outdoors. I used to
know someone who thought they could
exercise their dog enough by frenetically
playing with a ball with him indoors, and only
taking him outside for the quickest lav break.
This doesn't work. The dog, denied his basic
dog rights, was completely unsocialized,
frustrated, and eventually started displaying
behavioural difficulties.

- Make sure that there aren't any external factors
freaking him out. Sometimes a dog is fine with
being left for relatively long periods of time,
except that he is not fine at all if a car alarm
goes off, or if drilling starts on the building site
across the road, or if there's a thunderstorm.
You can't predict thunderstorms, clearly
(though you can sit through one with your dog,
soothing him and talking to him calmly if he is
frightened), but you can predict building work
and arrange for him to be elsewhere, and you
can get him used to car alarms by soothing and
cuddling him the next time one goes off while
you're there. These external factors putting a
spanner in the works are a particular shame,

because your dog is otherwise doing brilliantly. It
would be a pity for that to all go to pieces for
something you can swerve.

- You can buy CDs of sudden noises – thunder,
 fireworks, backfiring cars, burglar alarms and
 so on – designed specifically for dogs. Play
 them quietly while something else fun is going
 on, and gradually up the volume (don't deafen
 the poor dog!) until he is used to the sounds
 occurring in the background. Be ready to pat
 and reassure the dog if he doesn't like a
 particular sound, and bear in mind that there
 isn't a dog alive who thrills to the sound of
 fireworks, no matter what you do. It's fair
 enough, I think. Just don't leave your dog home
 alone on fireworks night (which seems to go on
 for about two weeks these days, unfortunately).

Holidays

Going away with your dog is easier than ever, not just
because pet passports still exist – though heaven knows
what happens once Brexit actually kicks in – but because
so many companies offer dog-friendly accommodation
in the UK (though do bear in mind that a vast number of

family-friendly British beaches are off-limits to dogs from Easter to September*). Whether you wish to put your dog in the hold of a plane is up to you; it is not, of course, a stress-free experience for the dog. Here are some thoughts if you're leaving him at home.

Dog-sitters are often cheaper than a residential stay at doggy day care – they're often students or older people who just really like dogs and who are happy to sit in your house writing their dissertation/pottering about while you're away, and who will feed, walk and play with your dog as needed. They can often be the best solution to a fairly intractable problem, plus at least your dog is in his own home. In addition, dog-sitters will water your plants, collect your mail and generally make sure the house is lived in, not lying empty waiting for burglars. Always interview prospective dog-sitters first. National agencies such as HomeSitters, which has been going for thirty-five years, vet their employees and are endorsed by insurance companies. You might also take a look at House My Dog (housemydog.com), where people local to you

* Having said that, there are always quieter, emptier alternatives nearby. But if you want the beach with the shop, the toilets and the café, it's probably going to be dog-free. This has happened because people don't pick up their dog poo and/or can't control their dogs. Sad state of affairs, really. If you *do* take your dog to the beach, always provide shade and extra water. Dogs love beaches, but not in August in 80-degree heat.

offer to look after your dog for a while. I see that dog hotels are also popping up in places like (of course!) Brighton. Charming idea, though of course the reality – loads of really excited dogs – won't have much to do with the mental image 'dog hotel' conjures up of a dog relaxing in a glamorous bathtub, reading *Dogue*, one languid paw occasionally reaching out for cheese from a silver salver.

I am personally not keen at all on kennels, because I think that a dog who is a beloved family pet will always find them extremely stressful. To me, they belong to the last century. The dog has no way to know that you haven't just dumped it there for ever, which is why a solution involving either his own home or known humans is always preferable. I don't like dogs in cages either.

Having said that, some kennels are significantly better run and friendlier than others: always visit a few before making your selection. Make sure your dog is vaccinated against kennel cough too. It's not always offered as standard and is associated with dogs being exposed to a large number of other dogs, hence its name (the infection is really called infectious canine tracheobronchitis). It can be fatal in severe cases.

To me, the best holiday solution aside from someone willing to dog-sit in your own home is a person who takes dogs in and has them live with him or her, usually in the country, for a week or two. How well this works absolutely

depends on your dog's temperament, of course, and only you will know whether it is a scenario your dog might enjoy – I think it requires being used to big groups and a certain degree of friendly chaos. But – I say this because a couple of my friends do this for a living and I have seen dogs staying with them first-hand – when dogs love it, they truly love it. Giant walks, lovely meals, cosy beds and very loving, cuddly human company: they're unsure for about five minutes, but after a couple of hours you feel they might almost be sorry to go home. Now: the people I know who do this do it for pin money because they're completely mental about dogs. That isn't a given. Always visit your dog's holiday let before committing him to it (anyone competent would also want to meet the dog she's about to temporarily adopt).

PET PASSPORTS

Depending on where you're going, the criteria for the pet travel scheme may include:

- Being microchipped – a legal requirement for every dog as of April 2016, whether you're planning to travel with him or not.
- Getting a blood test and a certificate showing you've done this.
- Getting vaccination against rabies (this can only happen with puppies aged three months or above) and a certificate, as above.
- Being treated against tapeworm and ticks, and having a certificate showing this.
- An official pet travel scheme certificate.
- Pet insurance.
- A declaration of residency.

You need to start planning for a trip abroad with your dog about seven months before your departure date. This is because your dog can't re-enter the UK within six months of having a blood test. All of the relevant, most

up-to-date information is available online at defra.gov.
uk. I'm just giving you the gist to show that you can't sud-
denly decide to take your dog to Ibiza for the holidays
on the spur of the moment. I would personally strongly
question the wisdom of taking your dog to Ibiza in the
first place, but anyway: plan well ahead. And do bear
in mind that this is all likely to change in the near future
when we leave the EU.

Chapter Eight

GROOMING AND PRETTINESS (AND HANDSOMENESS)

Some dogs take more grooming than others and you'll have chosen your breed accordingly. But all dogs need a degree of grooming maintenance, and it's a good idea to get them used to being handled for beautification purposes from the outset, not least because this is also relevant with visits to the vet. Since standing still and being primped does not come naturally to them, the first thing you need to do is get them used to that concept.

- I found the whole thing a lot easier if I used a specific surface for all of this stuff – namely, the kitchen table. You could perfectly well use the floor, but there's something to be said for the dog knowing that a particular surface means a

particular lot of happenings. Wherever you choose, accustom the dog to standing relatively still, by holding him lightly in place (treats and praise at the ready).

- Once he's fine with standing on the kitchen table (or wherever), without wanting to race off, gently look inside his ears.
- Once he's fine with ear inspections, gently open his jaws and look at his teeth.
- Once he's fine with teeth inspections, pick up a paw and have a feel of it, then look at the pads (puppies' footpads smell of biscuits, you will note). Then put that paw down and work your way through the other paws. You may or may not want to clip your dog's nails yourself (personally I am frightened of clipping into the quick), but it's good to get him used to the idea that someone will look at his paws and that this is perfectly OK. If you're comfortable wielding nail clippers, you should only ever cut off the pointy bit of the nail – no further.
- Once you've done paws, gently lift his tail to get him used to it. Eventually you'll be doing this to check for trapped poo, in longer-haired breeds.

- Check his eyes too. If they're unusually grubby (unlikely), you can swipe them with cotton wool and warm water.
- You may think that you don't especially need to prepare your dog for these various handlings and inspections because you plan to hand him over to a professional groomer for all of these things, but it's still a good idea to get the dog used to being handled: it means he won't find the groomer's overly stressful – or the vet's. Also, in the case of an accident – a splinter or bee sting or foreign body like a tick, you need to be able to examine your dog without him freaking out, which means he needs to learn to be relaxed about being examined.
- Don't make claws, which will dig into him uncomfortably – keep your palms and fingers flat and firm.
- As ever, reward and praise him for his polite cooperation.

BEE AND WASP STING EMERGENCIES

1. Bee stings: bee stings are barbed and the bee can't retract them. This means your dog is only stung once and the sting is left behind. You will be able to see it. Remove it with tweezers. Bee stings are acidic so you need to neutralize the area. The easiest thing to use at home is bicarbonate of soda mixed into a paste with water. This should help with the pain, which ought to start to slowly abate (it's bicarb, not antibiotics – give it some time).

2. Wasp stings: wasps can retract their stings, which means they can sting your dog multiple times. The stings are therefore not left in the victim after the stinging has occurred, so don't go looking for them. Wasp stings are alkaline. Applying any ordinary vinegar will help soothe the site of the sting.

3. If any sting gets worse – redder, hotter, angrier, causing increasing distress – despite your ministrations, go to the vet.

TICKS

Ticks are gross, and some ticks are especially gross and dangerous because they can spread Lyme disease, which can be fatal. The product you use to flea-proof your dog should also be anti-tick (including Lyme tick – ask your vet), but it's still worth knowing what to do if you find a tick – most probably in summer, after your dog has been in a densely wooded or grassy area (tall grass is heaven for ticks). So:

- Put on rubber gloves (and it's worth keeping a box of those disposable, *CSI*-style ones to hand if you're a dog owner; I get mine from the cleaning products aisle of the supermarket).
- Get either decent tweezers or a tick-removing tool.
- If using tweezers, get hold of the tick as close to the dog's skin as possible (i.e. not halfway up the tick's body). Steadily pull upwards. DO NOT TWIST or squeeze the tick because half of it will come off and half of it will stay embedded.
- If using a tick-removing tool, get as close in as possible to your dog's skin, as above, and slide the notch under the tick. Keep sliding it until the whole tick is caught.

- Disinfect the tick site and dispose of the tick (they don't die if you bin them or flush them down the loo – the best thing to do is to drown them in surgical spirit).
- Wash your hands and give the dog a treat for bravery.

Brushing

Brush your dog daily when he is a puppy to get him used to it. Don't assume that this really means 'twice a week' or 'when I remember'. Brushing removes dead hair and dirt: it's important, even in short-haired breeds, and essential in

longer ones. Longer coats can get all tangled up, and eventually matted, if you don't brush enough. You don't necessarily see the matting – which is extremely uncomfortable for the dog because it pulls like mad – as it starts close to the skin, especially in the armpits and legpits, and is covered up by other hair. If you have a high-maintenance breed, be especially vigilant about brushing, using an appropriate brush. There are lots of different kinds of brushes (in the past, I have found that a human Mason Pearson works well in extremis). Get him used to this from puppyhood, when his hair will still be short. Being brushed is nice – provided you're not yanking a comb through a load of snagged hair – and should not be stressful. Having said that, puppies will try with all their might to eat the brush or comb. Have a toy ready to offer for him to chew instead. There are different types of brushes:

🐾 **A slicker brush** looks like a spiky rectangle – it's made up of thin, short wires on a flat surface. The wires clean the coat and stop short of the skin. These are for medium-haired or curly-haired breeds, and for dogs with very thick, dense coats. Get the right size and don't press too hard. Essential for double-coated breeds like retrievers or German shepherds.

🐾 **A rubber brush** is made out of rubber. I don't really see the point of rubber brushes, except that I expect they feel quite nice, like being massaged. Hard to understand how they dislodge dirt or clean the coat, though.

🐾 **A wide-toothed comb** is good as an initial approach to long- or curly-haired breeds. Basically, use the same principle as you would on human hair: if it's massively curly, a wide-toothed comb is going to take out the initial tangles, and then you can go in with a brush afterwards.

🐾 **A bristle brush** is a good basic brush – you can use it on every sort of dog. Choose stiffer bristles for rougher hair, softer ones for softer coats. A good brush to finish with, because it adds shine to all coats.

🐾 **A pinhead brush** is made of metal bristles, which are longer than natural bristle. They don't remove a huge amount of dead hair but they're good at a final detangling.

🐾 **A stripping comb** is quite a serious bit of kit, since it strips (cuts) as it goes. These are designed to trim the undercoat of specific breeds.

🐾 **A grooming mitt** is used for very short coats. It's a mitten, so the dog thinks that you're stroking him rather than grooming him. Sneaky.

🐾 **An undercoat rake** will break up tangles and matts in a thick, dense or long coat. Make sure the pins are the right length for your dog's hair. They're really made for dogs who have a coarse top coat with a softer undercoat – the top coat is easy to maintain, but the soft undercoat is prone to knots and tangles.

🐾 If you encounter a matt or tangle, you will need to apply conditioner or detangler before going in with a **matt-splitter**. This is not enjoyable for you or your dog – better to keep on top of

brushing and not get yourself into this situation in the first place. If a dog is very matted, a groomer may shave him.

Professional Grooming

When to go to a professional groomer

Whenever you like, really, and as a matter of course if your dog needs his coat clipped. There isn't much point in taking a short-haired, sleek dog like, say, a dachshund to the hairdresser's, because there isn't much styling to be done (nails and so on are a different matter). But if your dog has a hard-to-manage coat, or you just want that coat styled in a particular way and don't trust yourself to administer the correct haircut (though your breed club will advise), then the groomer's is the perfect solution. It's like with your own hair: if every day is a good hair day, terrific. If you feel you could do with a professional cut or restyle, you go to the salon.

How to find a good groomer

By asking around. Find a smart-looking dog and ask his owner where he goes. Not all groomers are created

equal, by any means. Pick carefully: dogs' hair doesn't grow back that fast. I think it's always worth going on a salon recce before booking your dog in. Talk to the groomers; if you get the impression that the groomer, who is called something like Monsieur Antoine, would really rather be giving women elaborate 1970s hairstyles, make your excuses and leave. Tastes vary, of course, and you may actively want your dog to look like he's off to Crufts. I never do, not least because the 'breed standard' cut for Wheaten terriers is absolutely hideous. That's another thing: if you have a pedigree dog and wish to deviate from the 'show' norm, for heaven's sake say so, otherwise you may well find that you're picking up a bouffy, perfumed parody of your beloved pupster. It never does any harm to take in (or email) pictures of the cut you have in mind. The groomer might think you're a slight pain in the arse, but your dog will thank you. Also, don't assume that because you like the look of the groomer, you will like the cut he gives your dog. It's easy to think that you're on the same page because the groomer seems friendly, or has good tattoos, or is wearing nice trousers. It doesn't mean anything: they might still make your dog bouffy. The best haircuts Brodie ever had were from a borderline-hostile lady working out of a bare, bleak shop in suburban north London. The worst were from a hipster-looking place somewhere

more glamorous. So, assume nothing. Make your wishes crystal clear.

Check with your groomer what products they use

If you're keen to avoid sulphates, parabens and phthalates, all of which can cause terrible irritation, on yourself or your children, you may not be mad keen on them all being present in your dog's shampoo. In addition, pale-coated and white dogs are often treated with 'optical brighteners' – also used in laundry powders – to make their coats whiter/paler. You and your dog may not mind, in which case, fine. But it's worth asking if you don't much like the idea.

Baths

The only person who minds if your dog is dirty is you. It's certainly not your dog. He is delighted with his personal odour situation, especially if he's just rolled into something good and disgusting, like fox poo. If he hasn't rolled in anything and is just cheerfully going about his daily life, there is no need to bathe him unless you find he smells actively objectionable. Dogs smell of dog,

and this is simply a fact of life. You can't constantly deodorize them because you want them to smell of flowers instead. It's not good for them or their coats. Barring an incident involving fox poo/the bins/dead fish on the beach, once a month is enough.

Hose down muddy legs as required, obviously. If you're in a city, Hozelock make a contraption called a 4-in-1 PortaShower (about £30) that I have found invaluable. Mine has a five-litre plastic tank with a spray attachment – you pressurize it by pumping the lever up and down a few times. Fill it with hot water before you go for your walk, leave it to cool, come back and lo! Pressurized warm water to hose your dog down with on the pavement. It's really useful in winter or bad weather and it doubles up as a portable shower if your family contains anyone who goes camping/to music festivals.

Ears: these need to be checked once a week. If the inside of your dog's ears look iffy, give them a clean with cotton wool and warm water (only a tiny bit of water – squeeze out the excess. Water in the ear canal is not good).

Eyes: if you have a dog (usually white) who gets tear marks, you can buy proprietary eye wipes that tone the colour down.

Nails: city dogs don't usually need their nails trimmed because walking on concrete pavements takes care of it. For anyone else, nails need clipping. Only ever trim

the pointy bit. If you're nervous of doing this – I am, because unless the dog has white nails, you can't see where the dead nail ends and the quick begins – you can use a nail file.

- Decide where you're going to wash the dog – depending on his age and size, it can be quite a back-breaking business. The kitchen sink is excellent for puppies and smaller dogs (also babies and smaller children, in my experience).
- An actual bath works well for bigger dogs. Brodie is so used to baths now that he sometimes jumps in if my daughter's having a bath and has left the door open. If the dog is absolutely filthy – covered in mud or something sticky – and you have got nearly as filthy carrying him to the bathroom to spare your carpets, you can just take him into the shower with you.
- Outdoor baths are fine, but not in the depths of winter – see my Hozelock tip above.
- Water temperature needs to be as for a small child (i.e. not too hot).
- Pick a very gentle shampoo that's as natural (and therefore non-irritating) as possible. Human shampoo is not suitable. I like

shampoos that contain neem oil – great
for gloss and mildly antiseptic. You can
also add a couple of drops to an existing
shampoo.

- Two people are better than one, at least initially,
 until the dog gets used to the bath. Enlist a
 helper.
- Keep your dog's collar on loosely if you suspect
 he's likely to make a dash for it – that way you
 can hold on to him (this sentence sounds like
 I'm giving marriage advice).
- Dogs don't like their feet skidding about
 everywhere – put down a rubber mat (or
 an old towel) so that they have something
 to grip.
- Have a load of old towels to hand. Bathing
 dogs is a very wet business.
- If your bath or sink doesn't have a shower
 attachment/hose-like bit, consider getting one –
 even those cheap rubber ones from Boots are
 better than nothing. If not, arm yourselves with a
 couple of large jugs or pitchers.

Have treats – as well as shampoo, jugs and towels –
somewhere easily accessible. Call your dog to the bathing
area, using the treats if necessary. Put the dog in his

bathing receptacle and murmur encouraging things to him. Have about six inches of water in the bath/sink, less if your dog is tiny, more if your dog is huge. Using the shower or a jug, pour warm water over your dog's neck and back – leave his face alone for now.

Go easy on the shampoo. It's important that you are able to rinse every last scrap of shampoo off your dog, otherwise the residue can lead to skin irritation. So don't dollop on a giant squoosh. Start with his back, all the way down to the tip of the tail, and then do his legs, paws and undercarriage. Sluice it all off with the shower/jug (with clean water from the tap, obviously, not with the dirty, soapy water from the bath). Now get a clean flannel, dunk it in warm, clean water, and gently wipe down your dog's face. If he has long grubby whiskers, it's OK to use shampoo. Don't get any water in his ears – some people block them up with cotton wool for the duration.

As soon as you've rinsed your dog clean, leap into action with a dry towel. You're trying to put the towel on him before he shakes himself dry and soaks the whole room, which means you have seconds to act in. You may be too late, in which case never mind. Either way, lift the dog out of the bath/sink all wrapped in towel and gently pat him dry. Don't rub if he is a long-haired breed – that's how you get knots. I've never blow-dried a dog, though I know people do: low setting obviously, and plenty of

treats. Mine just air-dries, which he helps along by racing all over the house and rubbing his fur against the sofas. Comb/brush when he is completely dry.

Do not bathe your dog if you've flea-ed him in the past couple of days.

FOX POO

. . . is irresistible to dogs and it smells properly *disgusting*. One bath often isn't enough to get rid of the smell. You should as a matter of course buy a special fox poo shampoo as well as your ordinary one – I like Animology's Fox Poo Shampoo. For spot-cleaning, tomato ketchup works (yes, really; no, it's not an urban myth). It needs to be

Heinz, for safety, because some lesser tomato ketchups stain the fur of lighter breeds. Apply to the fox poo area and rub in, wait a bit, shampoo off. I expect it works because ketchup contains both acidic tomatoes and acidic vinegar, which means vinegar alone would probably do it too, but the smell of vinegar lingers almost as much as the smell of fox poo, so ketchup it is. If your dog rolls in fox poo a lot and you have to get him home on the crowded bus, rather than down a solitary lane, you could do a lot worse than have a few catering sachets of ketchup in your pockets. It'll nuke most of the smell, your fellow passengers won't start dry-retching, and you can deal with the rest when you get home.

DIY eyebrow trimming becomes necessary in long-haired breeds whose hair flops down in front of their eyes. I know it's supposed to do this, but they can't see out. Taking your dog to the groomer's because he needs his eyebrows trimmed is silly – you can perfectly well do it yourself. Be warned, though: it's a bit like deciding you're going to give yourself a fringe – 'I'll just snip all the way across, piece of cake' – in other words, not necessarily as simple as it looks. Always hold the excess hair

between two fingers, as though you were playing hair-dressers, and if you're nervous or it's your first time, use those blunt-ended (but not blunt-bladed) scissors you can get for babies. That way sudden head movements won't result in eye-spearing. Cut in a curve rather than straight down/across, which gives a weird square effect. Don't trim eyebrows, or anything else, when your dog is full of energy and raring to go on his walk – wait until he's tired and wearily compliant.

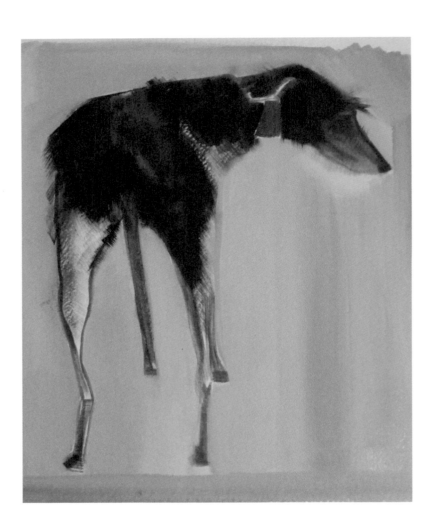

Chapter Nine

DOG FASHION

 When it comes to accessories, it's useful to separate the useful from the cringe-makingly terrible. Here's a good starting point: your dog isn't your baby.

'If you are a dog and your owner suggests you wear a jumper, suggest that he wear a tail,' the American writer Fran Lebowitz once said. I come from the same neck of the dog-fashion woods: I do not *at all* like to see a dog in clothes. I feel his humiliation, and the longing of his owner, expressed – apparently without embarrassment – so transparently and pitifully. Sometimes these people even get dog prams for perfectly healthy dogs who can walk. It's a wonder they don't breastfeed their dogs on park benches: tits out, who's a lovely mum? This whole dog-as-baby thing is a horrible vicious circle.

DOGS AND SOCIAL LIFE

Your social life changes completely when you have a dog, and even more so in cities. Within a couple of weeks, you spend disproportionate amounts of your time chatting to a whole new group of people – fellow dog walkers – for at least two hours a day. These are pretty much perfect relationships: easy, breezy, jolly – it's hard to be grumpy when you're walking your dog. You make lots of new dog-walking friends, and if there's someone you don't like, you have the perfect excuse to literally walk away. Your fellow dog walkers will be a useful mine of information, from who the best local vet is to dog-friendly businesses in the neighbourhood. If anything's up locally – a loony poisoning dogs, or something nicer like an upcoming dog show – the dog walkers will know. There'll be plenty of local gossip on offer too. Dogs offer a brilliant solution to the modern problem of loneliness anyway,* and the social life you can create through owning them is the cherry on the cake. Dog walking is also an excellent way

* You notice, in the chicer bits of Europe – Venice, Florence, Paris, Rome – that old ladies don't have husbands, just little dogs.

of engaging someone you like the look of in conversation, because everybody likes talking about their dog – I'm sure loads of relationships and marriages have their origins in dog walks. Also, quite aside from any of this, dog walking clears the cobwebs like nothing else. There isn't a problem or quandary that isn't improved by a dog walk. If a difficulty is like 3 a.m., when every worry seems to loom disproportionately huge, a dog walk is like waking up well rested with the sun streaming in: the problem's still there, but you feel like you might now be able to tackle it. Dog walking is really good for morale, not least because it is impossible to think exclusively about yourself when your dog is leaping and pirouetting, longing for you to play with him.

The sight of a dog in miniature clothes is demeaning and grotesque, to me – I po-facedly never find it cute or funny. There are exceptions: some short-haired, thin-skinned and very small dogs get so cold in winter that a dog coat is a sensible precaution, as with horses, rather than an act of honking madness. But a sturdy dog in bootees, or in a raincoat, or, as I once saw with my own eyes, *dungarees* – ugh. These dogs remind me of poor Janette

Krankie, who at least is a human. Also, I don't understand how you can love a creature and choose to express that love through making the creature comical or absurd. It doesn't mean you can't be playful occasionally, but think of how you'd dress a child. In a cow-print hooded Babygro with little ears: cute. With a cowbell round his neck and dangling udders made out of a rubber glove: wtf. The cut-off, wtf point very much also exists for dogs. Forgetting that dogs have their dignity is your own weirdness semaphoring loudly. It is not love.

None of that is to say that the desire for accessorizing doesn't throb deep within all of us. Our culture dictates that we lavish gifts upon creatures we love – that we express that love financially (depressing, really, but there we are). A dog's idea of a diamond necklace would be a marrow bone, but we ignore that and buy

him other sorts of presents instead. And that's fine. Buying things for our dogs is nice, and buying things to celebrate and prepare for the arrival of our dog is nice too. Here are some ideas (which, by the way, are all personal recommendations. No one's ever bribed me with free dog kit).

- Things for you: waterproof walking or hiking boots; waterproof jacket or coat with hood. You're far more likely to not cut rainy walks short if you have the proper kit and are warm and dry; that usually means Gore-Tex. If the jacket doesn't have loads of pockets, a small, light bag that you can wear cross-body is extremely useful for snacks, toys, poo sacks and the like, and it keeps your hands free. You could also buy a – dread word – BUMBAG for the same purpose.
- In my opinion, the best wellies are made by Aigle. They're not cheap, but they are ridiculously comfortable and you can walk for miles in them – not something I've found to be true of other wellies in the same price bracket.
- If you're in the country, you'll wear whatever's to hand: I dog walk in insane-looking, comfortable things (and always with a hi-vis vest on top after dusk. When it gets absolutely *pitch* black in an

instant, you never want to get caught short. Carry
a torch for the same reason).

- If you're in the city and mind about aesthetics,
 Protected Species (protected-species.com) make
 an amazing thin, warm, stretchy, unbulky,
 waterproof parka of impeccable design ('a
 masterpiece' – *Guardian*) that I can cannot
 recommend enough, not least because it's
 incredibly chic, flattering, breathable, efficient,
 and never gets sweaty-feeling.
- A dog lead and collar. Soft and pliable – fabric
 works – for a young puppy (check for fit weekly);
 leather or webbing for an older dog. There are
 hundreds of suppliers, but I especially like the
 leads and collars made by dogsandhorses.co.uk
 (padded leather, beautiful, comfortable and
 durable); those from hindquarters.com (both
 leather and fabric, exceptionally well made and
 chic); and the very sweet ones (fabric: think
 corduroy and Liberty prints) from lovemydog.
 co.uk, which look adorable on puppies and are
 soft and comfy. Also themagnificenthound.co.uk,
 which has beautiful leather and webbing collars in
 great colours.
- Most dog trainers dislike retractable dog leads, by
 the way, which they feel are too easy to get tangled

up in, can lacerate your hand, can cause serious falls, can cause traffic accidents, and encourage the dog to pull on the lead. I've seen loads of people falling over after getting tangled up in their own retractable dog leads, and then stagger up looking mortified with their hands all cut and their knees all grazed. Just get a normal lead.

- If your smallish dog is particularly excitable, he might be happier with a harness – have a look at mekuti.co.uk (among others, but highly recommended. This website is also a good source of neem shampoos).

- If your dog is problematic in any way, or even if you want to announce to the world that he is friendly, have a look at friendlydogcollars.com. They have bright, visible leads and coats that say things like NERVOUS, CAUTION, TRAINING, DEAF DOG, FRIENDLY, and so on.

- A dog bed for a more grown-up dog (as I was saying on page 84, buying a puppy a fancy bed is a waste of money because he'll chew it to shreds). I absolutely swear by Hindquarters' beds (website as above). They're a brilliant, comfortable shape, totally hygienic – the covers go in the wash – and deeply aesthetically pleasing. The filling is

hypoallergenic and the fabrics are natural. Lovely range of options, including denim and corduroy.

- Toys. As I mentioned in the chapter on leaving dogs at home, it's a good idea to invest in a small stock of puzzle games for dogs. But you also need toys to chew, toys that help developmentally and toys to take on walks. By the way, beware of tennis balls – a ridiculous exhortation if ever I saw one, but it's not a good idea to leave a dog unattended with one. Some stronger-jawed breeds tear them to bits and if they ingest the rubber they end up in hospital, having to have distressing and expensive surgery (like my dog friend Bob). By all means throw tennis balls for your dog, but then make sure he gives them back. Good tennis-ball tip: have two. Throw one, and if he won't give it back, throw the other one – he'll drop the first.

- Good toys include: Kongs, puppy teething rings (put in the fridge or freezer for cooling effect on inflamed gums); stag antler bars and chews (bits of antler, brilliant for chewing); squeaky toys (don't leave unsupervised – a terrier, for instance, destroys them in one go); tugging toys (but mind their new teeth!); dumbbell-shaped toys that float if your dog likes water. As I hope I've made clear,

I think raw meaty bones are better – and more
fun – than any plastic or nylon bone
approximation. There's something terribly sad and
poignant about a real dog with a fake, artificially
flavoured plastic bone.

• A proper, sturdy metal dog tag, rather than those
thin bendy ones that all pet shops sell by the till.
Have a look at reddingo.com, who do anything
from a really solid, completely plain, pleasingly
hefty brass tag to a giant array of equally solid
enamel tags featuring a range of designs from
stars to flags to peace signs. They also – sigh –
have diamanté ones, if that's more your thing.
Have the sign engraved with the dog's name and
your mobile number.

• Dog treats. Lots of dog treats are the dog
equivalent of sweets – only a treat in the most
bad-for-you, messed-up human sense. I like using
Nature's Menu Real Meaty treats – which count as
high-value, as per page 157; Lily's Kitchen Truly
Natural Little Liver Rewards (nutritious dried
beef liver, nothing else); Lily's Kitchen Fish Skin
Dog Chews (nutritious fish skin, nothing else);
and cheese . . . any cheese. And scraps of leftover
meat – which you must not leave in your pocket
and forget about.

Please don't anthropomorphize your dog. He is a dog. He does not enjoy 'pamper parties' that involve painting his nails with polish (these exist, and are the merest tip of the most monstrous iceberg. That whole scene is *so* messed up). It is ludicrous and wrong to decide, like a crazy person who can't stop projecting, that your dog sees the world exactly as you do, and that he will therefore enjoy the same things as you. In the process, you lose any concept of your dog's wonderful dogness. This is bad, sad news for your dog, and a dreadful shame for you as it means you're choosing to ignore canine behaviours, and by extension refusing to learn from what we know about dogs, and from what your own dog teaches you daily. I don't want to sound like a massive hippie, but that's a really sad loss.

You can make sense of your dog's actions without pretending he is a human. It's easy: dogs are not complicated creatures.

Anthropomorphizing also leads to humans deciding that their dog is 'guilty' or 'embarrassed'. That he 'knows' when he's done wrong. Actually, that 'guilty' look happens when you're cross with your dog and he can't understand why. He's trying to diffuse your anger. He's completely confused, and his expression reflects that. Learn to tell the difference between your dog and a human child. Your dog is not your baby. He is a domesticated wolf. He is very clever, but he does not have, or display, the same array of emotions as you, no matter how keen you are to ascribe them to him.

This does not mean that he does not have an intense emotional life, or that you do not have an intensely emotional relationship with him, with his lovely dog self and with his uniquely expressive face (alone of all the pets, dogs have evolved expressions, unlike, say, cats). Of course you do, and it is absolutely rooted in mutual love. But your dog is not 'proud' of his new bandanna or 'embarrassed' because he missed catching the stick you were throwing for him.

Does this matter? Not remotely. Your amazing dog loves you. He is capable of experiencing deep joy (as well as anxiety, fear and anger, just like you). Focus on the

love and the joy. They're a great deal more important than him 'knowing' he shouldn't have knocked that vase over with his joyful waggy tail.

Having said that, I have quite a lot of time for anthropomorphically ascribing an internal dialogue, and a particular voice, to every dog I meet. My friend who has a pug started it: her pug would waddle about and my friend would give a running commentary of the imagined content of her dog's head, in the pug's voice, which happened to be the voice of a world-weary, seen-it-all, elderly New York socialite. The pug would say things like, 'Yada yada yada, tell it to the Marines,' or – with acid disbelief – 'Sure, baby. Uh-huh. Sure,' and then turn around and mutter, 'Asshole,' to herself. On holiday, she would give brutal evaluations of people on the beach. It was very funny. There's a dog I know that I don't really like that much, and in my head he speaks like a man who wears grey shoes and neat 'slacks' – quite nasal, slightly naff, prone to saying things like 'my good lady wife', keen to discuss the traffic and the novels of Jeffrey Archer. He makes shit jokes and says, 'Language!' if anyone swears.

My friend's black Labrador basically wanders about saying 'bloody good chap' about other dogs, unless he meets ones he doesn't like, in which case he says 'bloody poor show'. 'Chaps' is his favourite word – 'Any chance

of those little treat chaps?', 'This boot's a tasty chap,' 'Ah, a baby chap,' and so on. This is quite an obvious voice for this dog – black Labradors are the north Norfolk of the dog world (posh); chocolate Labs the Cotswolds (think they're posh), so clearly the black Lab speaks like his owner's estate has been in the family for 600 years. It would have been far funnier if I'd made him speak like a pugnacious Glaswegian – alas, I did not have the presence of mind to think of this at the time. But, you know – a miniature poodle, super-bouffed, who swore like a navvy would be pleasing, or a Staffie who was obsessed with Farrow & Ball. A doll-faced bichon frise who was grossly impolite ('Fuckin feed me, mofo'). A Peke who was a butch lesbian. A Yorkshire terrier who was a brigadier. You get the idea. Brodie, for reasons I can't entirely explain, used to speak with a slight Japanese accent. These days his accent is standard English, though he occasionally swerves into deep, barely intelligible rustic, especially when he makes observations about the enduring power of nature and the transience of the self.

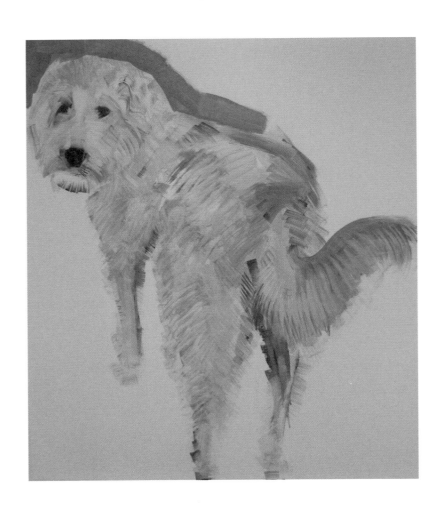

THE ADOLESCENT DOG AND BEYOND

Adolescence in dogs is reached at about six months, though it builds up before that: one day your puppy is not quite as puppyish, doesn't rely on you quite as much, and is more independently minded than he used to be (he also ignores his curfew, raids the cereal cupboard at 2 a.m., doesn't put his bowl in the dishwasher and probably smokes weed). So warning signs may come earlier, but actual sexual maturity is reached at roughly six months.

You will know because bitches come into season for the first time – they may, prior to this, exhibit all the short-tempered, irritable, snappy signs of human PMT – and dogs, whose testosterone levels are rising, will start peeing with their leg cocked. They will also sniff about for any local bitches and begin to make an especial point of marking out their territory. Bitches may get aggressive

with other female dogs and male dogs may get scrappy with fellow male dogs.

In teenage dogs, as in human teenagers, the outside world will have never seemed so wild or attractive or exciting. This may mean that your dog now starts paying less attention to what you want him – and have carefully trained him – to do. You'll be familiar with this phase if you have teenage children: it's quite annoying, but it passes. As with teenage children, the important thing is to plod on: maintain boundaries, even when you are thinking, 'God's sake. I've got a lot going on. I can't be bothered with this nonsense.' Understand that your dog is newly mad about exploring the big world out there, and let him roam, but know that this is no time to stop with the training or to let it slide, or to be pointlessly forgiving when your dog ignores your benign instructions. Keep praising and rewarding good behaviour; keep turning your back to bad behaviour. Keep training your dog until he is at least one year old, even if it temporarily looks like he's forgotten everything you've taught him. Do not lose heart. I'm loath to keep comparing dogs to teenage children, but really – there *is* tremendous overlap. This includes testing you to see how far you'll bend before you snap. Don't snap, obviously. Bend a little, but try to stay broadly upright. Your dog's temperament is

still being shaped, and we want to keep it being shaped positively and along the right track.

For these small negatives, there's one huge, massive positive. Puppies love pretty much everybody, you included. Stick by teenage dogs and see them through it, and they will eventually make it crystal clear that they love you the most, and that this is their choice, freely made. That bond, now cemented, lasts for the rest of the dog's life. So that's pretty beautiful and special, and hopefully makes up for the times when you may have to pelt round the field/park, calling your dog and being roundly ignored because the big wide world is so deeply fascinating.

By the way, adult teeth bed in around now, which means a renewal of obsessive (and biologically necessary) chewing. Be prepared, and don't be annoyed. All their teeth feel like your wisdom teeth did. The least you can do is provide them with fresh bones.

Adolescence ends . . . when it ends. It kind of depends on the breed and the individual dog. Sometimes it takes months, sometimes a bit longer. If you're wondering how much 'a bit longer' will take, ask your breeder. I wouldn't, though. I'd just go with it. Your dog goes with you, with your moods and your peculiar behaviours, every day of his life. Cut him some slack.

SPAYING AND NEUTERING

Always get your dog neutered or spayed unless you are planning on breeding from them. Neutering and spaying will make them much calmer, less aggressive and generally nicer to be around. It will reduce unwanted sexual behaviour, such as mounting and boners, or pelting dementedly out of the house if a local bitch is in heat. In bitches, it will reduce (or remove) the behaviours associated with their coming into season for three weeks at a time, twice a year, and get rid of the bloody mess this involves. In both dogs and bitches, neutering/spaying has significant health benefits, including reducing or removing certain cancer risks.

In a world awash with unwanted, abandoned dogs, it is the sane and responsible thing to do. Neutering involves getting rid of the testicles; spaying involves removing the ovaries and uterus of a female dog. It sounds quite dramatic but is wholly routine and you can have it done from six months onwards. You may also find that it calms your adolescent dog down considerably.

Beyond adolescence, your dog just becomes . . . your lovely dog. The moments of biological change, the steep learning curves, the constant training and reinforcing – all of that is pretty much done with. Now it's you and your dog, compadres for life. There may still be occasional dramas, there will certainly be no shortage of adventures, and there will be lots of hilarious incidents (retrospectively if not in the moment). And none of this means that your dog suddenly stops needing mental stimulation, or that his appetite for your company has lessened, or that he's decided he hates being walked. But the vibe is different – more companionable, more atuned, less frenetic. Congrats – you are now simply a person with a dog, which means you are one of the luckiest people on earth.

Common Dog Diseases

Take heart: many of the major illnesses are entirely avoidable through vaccination.

🐾 **Bloat, aka gastric torsion** This happens when the stomach twists in on itself, usually because it contains too much air. It is most likely to happen in deep-chested breeds, though the reasons aren't entirely clear. Anxious dogs are thought to literally swallow air, to the point where a very stressed dog may get bloat. It can also be caused by diet, where a dog eats food that is so fermented that it produces gas once consumed. If your dog is drooling when he doesn't usually drool, if his stomach seems distended and if he is taking in too much air, see your vet urgently.

🐾 **Canine distemper** This is a virus that attacks the lining of the lungs and the central nervous system. Your vet will vaccinate against it.

🐾 **Hepatitis** This is also vaccinated against.

🐾 **Kennel cough** (see page 196) Again, your vet will vaccinate at the earliest opportunity.

🐾 **Lungworm** This is a parasite that is often

caught by eating garden pests like slugs and snails (though obviously not all slug or snail eating will result in lungworm). Dogs can also catch it from dirty outdoor drinking bowls, swimming in the murkier ponds, being anywhere humid and swampy, and even from manky sticks. Foxes can carry lungworm too. There are not always obvious symptoms, though when symptoms do appear, they often include shortness of breath. Not leaving old toys to half rot outside and making sure your dog is regularly wormed should avoid lungworm.

- **Lyme disease** (see page 205) Keep your dog up to date with his monthly flea treatment. Frontline and Advantix both protect against ticks as well as fleas.
- **Parva** (short for canine parvovirus) This manifests itself in vomiting and diarrhoea. Dogs become very sick indeed. It lasts a few days, can be fatal and is highly contagious. It is most prevalent in young, unvaccinated puppies. You can and should vaccinate your puppy against parvo at eight weeks.
- **Weil's disease** As with humans, this is contracted by drinking water infected by rat

pee, such as the water in stagnant ponds. Your
vet can vaccinate.

Dogs can and do get themselves into scrapes. If your dog
is up to date with his vaccinations, clean and disinfect
cuts and scratches yourself and keep an eye on them.
Show them to the vet if there is even the possibility that
they are getting worse. Deep bites or cuts should be seen
by the vet straight away.

Grass seeds in the paw pads sounds almost sweet but
can cause terrible grief. Some grass seeds are extremely
sharp and arrow-shaped, and can travel through skin to
lodge themselves deeply and cause agonizing pain. Long
or shaggy-haired dogs are most at risk, and grass seeds
are obviously most common in long grass, meadows and
woodland. They usually embed themselves either in the
paw or in the ear. If your dog is hobbling, obsessively
licking his paw or shaking his head/ears as though try-
ing to dislodge something, and you've discounted any
other logical explanation, this may be a grass seed issue.
Go to the vet straight away.

Broken bones obviously require immediate veterinary
attention. Young dogs heal faster than older dogs and
very large or very tiny breeds heal more slowly than
average-sized breeds. After surgery, your dog may have
to have bed rest (which might well mean going back to

the crate, page 77) for up to three months. The good news is, dogs' bones heal very well and, after the period of convalescence, your dog will be as good and chipper as new. Well, nearly.

MIDDLE AGE AND BEYOND

Dogs stay pretty giddy through their adolescence. It is only when they reach middle age – their prime, in dogs as in humans – that you really notice their true character. Dogs are the noblest of creatures, but it's not always easy to see it when they're racing about being skittish puppies and teenagers. So don't think to yourself (as if you would!) that because your adult dog is somehow not as fun, or as silly, or as endearing as he was when he was a puppy, he is somehow *less* than he was. Nothing could be further from the truth. He is growing in stature every day. Look at him, standing proudly with the wind in his ears, looking out across the land. He is magnificent. What you experience with an adult dog is really essence of doghood.

THE NOBILITY OF DOGS

As best captured by this outstandingly moving poem. Tissues ahoy, is my advice.

SHACKLETON'S DECISION
Faith Shearin

*At a certain point he decided they could not afford
the dogs. It was someone's job to take them one by one
behind a pile of ice and shoot them. I try to imagine
the arctic night which descended and would not lift,*

*a darkness that clung to their clothes. Some men objected
because the dogs were warmth and love, reminders*

of their previous life where they slept in soft beds,
their bellies warm with supper. Dog tails were made

of joy, their bodies were wrapped in a fur of hope.
I had to put the book down when I read about the dogs
walking willingly into death, following orders,
one clutching an old toy between his teeth. They trusted

the men who led them into this white danger,
this barren cold. My God, they pulled the sleds
full of provisions and barked away the Sea Leopards.
Someone was told to kill the dogs because supplies

were running low and the dogs, gathered around
the fire, their tongues wet with kindness, knew
nothing of betrayal; they knew how to sit and come,
how to please, how to bow their heads, how to stay.

With the giddiness (mostly) over, the dog and you are
now equals. You'll absent-mindedly turn to your middle-
aged dog and say, 'Remind me to plant out the dahlia
tubers' or 'God, I can't believe he said that, can you?'
in a way that you wouldn't with a younger dog. This is
because you know that your grown-up dog is now cap-
able of these sorts of conversations, and finds the minutiae

of existence as interesting as you do. Young dogs really only ever see the broader picture. Young dogs, if they were a sentence, would be 'Wheeeee!' Older dogs can zone in on the detail. If they were a sentence, they'd be 'Yes, I see.' It's absolutely marvellous.

These are the years when the dog stops being like a slightly demanding child and becomes a true companion. They are, if you like, the years after the mad whirlwind romance, when you settle down comfortably, make each other laugh like drains and yet still find each other powerfully attractive, which feels like a slightly creepy thing to write about a dog, but you know what I mean – which isn't that these are the peak years of *fancying* your dog, but that you still find him very, very handsome and great. You glance over at him sleeping by the fire, or watch him come running towards you, and you think, with a sort of sober certainty, 'What a handsome, clever dog. How lucky I am.' The time for squealing ('Oo is my pupperoo?') and hyperbole is past. What you have together now is a wonderful solidity. You are a bonded pair: dog and owner. Just two strong pals. As the years go on, it isn't entirely clear who is helping and supporting the other the most. This can feel like peak love. Imagine a couple, not in the absolute first flush of youth, driving along in a topless car somewhere sunny, hair and ears streaming elegantly in the wind. That's how I feel about

middle-aged dogs. They are intensely lovable, and also somehow poised and self-contained. I think it's because they really know themselves.

This doesn't mean that nothing can go wrong, because of course it can. But your dog is far less likely to suddenly do something dangerously bonkers than he was in his youth. He's close to unflappable these days, unless his routine is really brutally disrupted. He's less needy too: he knows that no means no; he knows that there's no point in begging at the table because nothing ever comes of it; and he has accepted, or resigned himself to, the fact that you can't necessarily be around 24/7. This dog is chilled.

Does Older Mean Stinkier?

No, it most certainly does not! Having said that, it absolutely used to be the case that older dogs smelled worse than younger dogs, and that we all thought this was just the way things were. Stinkiness was almost expected. It's really quite odd, thinking about it. I mean, what an assumption! Older people don't smell worse when properly cared for, and there's no reason dogs should either.

The first thing to understand is that dogs smell of dog, not of mint shower gel or Chanel N°5. This dog smell is

lovely, though (temporarily less lovely if a dog has become very wet). It's the smell of your dog, whom you love. So, not the kind of smell you wish you could bottle and spray lavishly all over yourself, but very far from unpleasant. If a dog smells bad, there is always a reason.

- He's rolled in something revolting or dead (or both). Give him a bath, and see page 217 for help with fox poo and other especially tenacious smells.
- He's decided to have an impromptu bath or swim in brackish water. Give him another one in a clean tub.
- He has an infection of some kind, probably yeast-based. Check his ears and paws for redness

or irritation (you should really be checking his ears and paws once a week anyway), and if one of them's the culprit, take your dog to the vet for medication. Ear infections or ear mites are incredibly common, often lie undetected for ages and eventually cause your poor dog to smell horrible. They're very easily cleared up with a course of antibiotic drops.

- If it's a more faecal or fishy smell (waaah), then it's probably to do with impacted, inflamed or infected anal glands (see page 120), especially if your dog is dragging his bottom along the ground in a scooting motion. These need immediate attention for everybody's sake: go to the vet. See also the note re diet on page 120.
- If the bad smell is to do with excessive farting, I refer you to the same note re diet on page 120. Whether you 'believe' in raw feeding or not, something's not right if you're feeding a diet that makes your dog flatulent at all times (which is uncomfortable for him, aside from anything else – nobody likes being a martyr to gas). Flatulence means that whatever you're feeding him persistently doesn't agree with him and may be causing him serious discomfort. It may be that sharing your sausage roll with him

doesn't agree with him, which is easy enough to stop, or it may be that you're feeding him the wrong dog food. Change his diet.

If you don't have the first clue about how to do this, start with feeding your dog boiled chicken and rice, which are bland, eminently digestible and contain no weird crap. Boil some boneless chicken pieces; cool and shred. Boil some rice; drain and cool. Combine the two and add a little water if the mixture is too dry. Feed to your dog instead of his usual food for a couple of days while you seek advice. It may get worse before it gets better – any sudden change of diet takes a bit of getting used to – but persevere. You could lob a tablespoon of plain full-fat live yoghurt in there too, for the gut-boosting probiotics. By the way, this is a good recipe to have to hand whenever your dog is under the weather, feeling delicate or recovering from eating something he shouldn't have, like chocolate. It's the home-made equivalent of the tins of special bland, digestible food that you can buy at the vet's.

- Abdominal stinks can also be related to infection, so see your vet if you suspect that might be the case.

- Dog breath should not be offensive, unless your dog has just eaten something rank that he found lying about in the woods or bins. Maintain good oral hygiene by offering raw meaty bones (see page 124), which act as a toothbrush and dental floss combined.
- Skin complaints are often also diet-related.
- The long and short of it is that no dog should smell horrible all the time. If your dog constantly smells bad, take him to the vet. If the vet is the kind of vet who suggests swapping Food A (which he sells) with Food B (a variant of Food A, which he also sells), and you suspect that diet may be the issue (it often is), try another vet.
- For the reasons outlined on page 115, vets who enthuse about raw feeding are not six a penny, though they do absolutely exist. If you're desperate, take a look at holisticvet.co.uk, who offer phone or Skype consultations worldwide on the subject of raw feeding (after consultation with your existing vet).
- Terminal illnesses like cancer do generate their own smell, horrible as it is to say so. If your dog is terribly ill, he may not smell divine.

Does Older Mean Fatter?

Dogs, like people, can tend to run to fat in middle age. Remember that if your dog is slowing down a bit he probably doesn't need the same quantities of food as he did when he was super-active and ran non-stop for two hours a day. Obesity is no better for dogs than it is for humans. If your dear dog is looking on the tubby side, take appropriate measures. Your vet will advise, but it's not rocket science: serve slightly smaller portions until the portliness abates. You can also try swapping calorific treats for more diety ones, like carrots. Some dogs really love carrots. Brodie despises them.

HOW TO TELL IF YOUR DOG IS FAT

- You should be able to feel his ribs and the spaces between them without applying an undue amount of pressure. If you have to poke quite hard and can feel a layer of fat, he's fat.

- Your dog should not seem knackered after only minimal exertion if he is a healthy weight.
- Your dog's digestion should be working well.
- Look at him: in profile, chest to shoulders should look like a triangle on its side, with the narrow end towards the legs. If the area looks like a square or rectangle your dog is fat.
- Dogs have a waist, of sorts. If, viewed from above, your dog is bulgy around his middle it's time for smaller rations.

If there is no obvious reason for the weight gain – no decrease in exercise or activity, no snaffling of extra treats – get your dog checked by the vet. Dogs can and do suffer from thyroid problems, among other possible causes.

The thing about dogs and ageing is that you are ageing too. Depending on how old you were when you embarked upon the great adventure of dog ownership, you may find that there is something rather beautiful and elemental about your conjoined trajectory and its gradual slowing down. Perhaps neither of you is able to gambol as freely as you once did; perhaps you both enjoy taking walks easy these days. Or perhaps you're thirty-two and

understandably unable to cope with even the *idea* of dog (or human) decrepitude.

When the day comes – and hopefully it is very, very far away – it is important to remember that it's your duty to provide your beloved companion with a good death, as well as a good life. This does not necessarily mean prolonging your friend's life for as long as you can just in order to keep him nominally alive. Quality of life matters too. It is tragically sad to have to think about any of these things, but in all likelihood your dog will predecease you and think about them you must. But not right now, perhaps. Read the following chapter when the time comes. And until then, enjoy the best years of your wonderful dog's life. Dogs! They're so bloody great. They are such a *privilege*. We are so infinitely lucky to know them.

DOGS IN HEAVEN

 Yes, in heaven. The Pope, leaping gracefully over centuries' worth of agonized theological debate about whether or not animals have souls, hinted in 2014 that dogs do go to heaven. Well, I say 'hinted' – I decided on the spot that there was no hint about it whatsoever and that His Holiness had in fact pronounced. What he actually said was, 'The Holy Scripture teaches us that the fulfilment of this wonderful design also affects everything around us,' and that 'what lies ahead . . . is therefore a new creation'. He added: 'It is not an annihilation of the universe and all that surrounds us. Rather it brings everything to its fullness of being, truth and beauty.' The Italian daily *Corriere della Sera*'s Vatican correspondent wrote the next day that

the Pope's words broaden 'the hope of salvation and eschatological beatitude to animals and the whole of creation'. I'm with his interpretation. What kind of heaven has no dogs in it?

There is a wonderful cartoon by Charles Barsotti, probably the greatest cartoonist of dogs. It shows a man standing on a cloud in front of a beaming St Peter, who has his list on a desk along with ink and a quill. The man, clearly a new arrival, is in late middle age and his expression is one of astonishment. To the right of the drawing is a beaming, jaunty little dog, tail wagging, hurtling joyously towards the middle-aged man. The caption, as spoken by St Peter, reads: 'So you're little Bobby. Well, Rex here has been going on and on about you for the past fifty years.' Do you see? The dog died when middle-aged Bobby was 'little' *and the dog has been waiting for Bobby ever since.* God, I can hardly bear to type it, it's so moving. And Bobby is looking astonished because – well, because here is Rex, beloved companion of his boyhood, flying towards him with his tail wagging, after *fifty years of waiting.* It's too much. It also perfectly captures both the joy and the loyalty of dogs. This cartoon and the Pope's words basically make me believe in heaven. There is a poem by Pablo Neruda (this translation by

Alfred Yankauer) called 'A Dog Has Died', which contains these lines:

> *and I, the materialist, who never believed*
> *in any promised heaven in the sky*
> *for any human being,*
> *I believe in a heaven I'll never enter.*
> *Yes, I believe in a heaven for all dogdom*
> *where my dog waits for my arrival*
> *waving his fan-like tail in friendship.*

Look, I don't know what to write to make you – and myself – feel better about the fact that one day our adored dogs will die. I can reduce myself to tears thinking about the fortitude with which dogs I have known over my life – even dogs I didn't especially like – bore their

suffering and decline. But do you know what? I also remember the love and devotion given so freely to those dogs by their owners, and one of the reasons this stuff chokes me up is that, to me, the combination of human kindness and patience and heartbreak is an expression of love in one of its purest forms. People – even bad, silly, not-nice people – are capable of behaving with astonishingly selfless love and compassion when their dear dogs become ill. They turn themselves into heroes. It is desperately sad, but also desperately affecting.

Some dogs are perfectly fine and just eventually die of old age, in the same way that some people do. This seems the best possible end for both humans and dogs.

Some dogs decline in the way that some people do. They lose bits of themselves: their teeth, their powers

and sometimes half their marbles. They can become incontinent, or lame, or blind, or deaf, or all four, with a whole slew of additional possibilities waiting in the wings. (On a pragmatic note, please make sure that your pet insurance is up to speed – now's not the time to cancel it because you want to see if you can get it cheaper elsewhere, and then get caught up in something else and forget about it.) Arthritis can often strike, and is more likely to do so in breeds that have inherited disorders in their joints. Kidneys can start to fail, and will require a special low-purine diet if they do. If you haven't been as vigilant as you might have been about oral hygiene (it's never too late to start), gum disease can set in.

Caring for a dog in his declining years or months is like caring for a person. Your heart will be heavy, but that doesn't mean that you lose the ability to apply common sense to the situation. If your dog has difficulty moving about, and usually sleeps upstairs, move his bed downstairs (if he sleeps with you, carry him up. One old lady I know used to put the dog on her lap on the stairlift and they both silently used to go whirring up, with immense dignity). Keep him as physically close to you as you can: he will be bolstered by your proximity. Keep talking to him, and stroking and cuddling him. Keep gently grooming him. There's no need for your dog to be like an old person who nobody cares about enough to

shave or give a haircut to. Let your dog be the old gent with brilliantined hair and a crisp kerchief poking out of his jacket pocket. Keep an eye on his surroundings too. Just because he's on his way out doesn't mean he has to lie on a stained, smelly bed that's on its way out too. Keep things clean and squared away, even if this involves its own laundry schedule. It's good for morale, like clean sheets and a bright, sunny room.

By the way, it is absolutely normal to feel *bereft* after the loss of a dog. Don't try and process it too quickly, or feel embarrassed when you burst into tears months after the event. Don't feel you ever have to say, 'I don't know what's wrong with me. He was only a dog.' Losing a dog to illness is bad enough, and losing a dog unexpectedly, to a traffic accident, for example, is also nightmarish. Take as much time as you need to grieve properly. This adored creature has been a daily part of your life for as long as you can remember. It is entirely correct that you should mourn him deeply. Dog owners often love their dogs more than they love some people. It follows that their grieving is profound.

Your dog may die naturally; you will of course make sure that things are as comfortable and comforting for him as possible. If the death does not occur spontaneously, when the moment comes and you can see that the game is up, or when the vet gently suggests that it might

be time to put your beloved companion down, spare your dog the chilly, depressing anonymity of the surgery. Do as my former mother-in-law has always done: ask the vet for a home visit instead. Arrange it so that children, and any other people who love him, can be there too if they wish to be. Stroke and cuddle your dog, somewhere cosy, familiar and comfortable. Feed him a last delicious snack or six. Say your goodbyes, taking as long as you need. If your dog seems anxious or uncomfortable, ask for him to be mildly sedated. When the time comes, he will barely feel the needle going in and will die in your arms, or on your lap, which is to say in his favourite place in the whole world. You are, and always have been, the centre of his world. Do not let him down now because you can't bear it or it's too upsetting. Let him die as he has lived: loved beyond words, in his best friend's arms.

ON A GOOD DOG
Ogden Nash

O, my little pup ten years ago
was arrogant and spry,
Her backbone was a bended bow
for arrows in her eye.
Her step was proud, her bark was loud,
her nose was in the sky,
But she was ten years younger then,

And so, by God, was I.

Small birds on stilts along the beach
rose up with piping cry.
And as they rose beyond her reach
I thought to see her fly.
If natural law refused her wings,
that law she would defy,
for she could do unheard-of things,
and so, at times, could I.

Ten years ago she split the air
to seize what she could spy;
Tonight she bumps against a chair,
betrayed by milky eye!
She seems to pant, Time up, time up!
My little dog must die,
And lie in dust with Hector's pup;
So, presently, must I.

A FEW GOOD DOG THINGS TO SEE YOU ON YOUR WAY

Here are some things I've gathered together in a randomish fashion – things I've read and liked, things that will be useful too. First off, a sort-of poem by dog behaviourist Stan Rawlinson called 'The 10 Commandments from a Dog's Point of View' (1993).

1. My life is likely to last 10–15 years; any separation from you will be painful for me. Remember that before you buy me.
2. Give me time to understand what you want from me; don't be impatient, short-tempered, or irritable.
3. Place your trust in me and I will always trust you back. Respect is earned not given as an inalienable right.

4. Don't be angry with me for long and don't lock me up as punishment; I am not capable of understanding why. I only know I have been rejected. You have your work, entertainment, and friends, but I only have you.
5. Talk to me sometimes. Even if I don't understand your words, I do understand your voice and your tone. You only have to look at my tail.
6. Be aware that however you treat me, I'll never forget it, and if it's cruel, it may affect me for ever.
7. Please don't hit me. I can't hit back, but I can bite and scratch, and I really don't ever want to do that.
8. Before you scold me for being uncooperative, obstinate, or lazy, ask yourself if something might be bothering me. Perhaps I'm not getting the right foods or I've been out in the sun too long, or my heart is getting old and weak. It may be I am just dog-tired.
9. Take care of me when I get old. You too will grow old and may also need love, care, comfort, and attention.
10. Go with me on difficult journeys. Never say, 'I can't bear to watch' or 'Let it happen in my absence.' Everything is easier for me if you are there. Remember, regardless of what you do, I will always love you.

Here is author E. B. White's obituary for his dog Daisy from
E. B. White on Dogs, edited by Martha White (2013):

Daisy ('Black Watch Debatable') died December 22, 1931,
when she was hit by a Yellow Cab in University Place. At the
moment of her death she was smelling the front of a florist's
shop. It was a wet day, and the cab skidded up over the
curb—just the sort of excitement that would have amused
her, had she been at a safe distance. She is survived by her
mother, Jeannie; a brother, Abner; her father, whom she
never knew; and two sisters, whom she never liked. She was
three years old.

Daisy was born at 65 West Eleventh Street in a clothes
closet at two o'clock of a December morning in 1928. She
came, as did her sisters and brothers, as an unqualified sur-
prise to her mother, who had for several days previously
looked with a low-grade suspicion on the box of bedding
that had been set out for the delivery, and who had gone into
the clothes closet merely because she had felt funny and
wanted a dark, awkward place to feel funny in. Daisy was
the smallest of the litter of seven, and the oddest.

Her life was full of incident but not of accomplishment.
Persons who knew her only slightly regarded her as an opin-
ionated little bitch, and said so; but she had a small circle of
friends who saw through her, cost what it did. At Speyer
hospital, where she used to go when she was indisposed, she

was known as 'Whitey,' because, the man told me, she was black. All her life she was subject to moods, and her feeling about horses laid her sanity open to question. Once she slipped her leash and chased a horse for three blocks through heavy traffic, in the carking belief that she was an effective agent against horses. Drivers of teams, seeing her only in the moments of her delirium, invariably leaned far out of their seats and gave tongue, mocking her; and thus made themselves even more ridiculous, for the moment, than Daisy.

She had a stoical nature, and spent the latter part of her life an invalid, owing to an injury to her right hind leg. Like many invalids, she developed a rather objectionable cheerfulness, as though to deny that she had cause for rancor. She also developed, without instruction or encouragement, a curious habit of holding people firmly by the ankle without actually biting them—a habit that gave her an immense personal advantage and won her many enemies. As far as I know, she never even broke the thread of a sock, so delicate was her grasp (like a retriever's), but her point of view was questionable, and her attitude was beyond explaining to the person whose ankle was at stake. For my own amusement, I often tried to diagnose this quirkish temper, and I think I understand it: she suffered from a chronic perplexity, and it relieved her to take hold of something.

She was arrested once, by Patrolman Porco. She enjoyed practically everything in life except motoring, an exigency to which she submitted silently, without joy, and without nausea. She never grew up, and she never took pains to discover, conclusively, the things that might have diminished her curiosity and spoiled her taste. She died sniffing life, and enjoying it.

Some Books You Might Like

John Bradshaw, *In Defence of Dogs: Why Dogs Need Our Understanding* (Allen Lane, 2011)

Brian Hare and Vanessa Woods, *The Genius of Dogs: Discovering the Unique Intelligence of Man's Best Friend* (Oneworld Publications, 2014)

John Homans, *What's a Dog For? The Surprising History, Science, Philosophy, and Politics of Man's Best Friend* (Penguin, 2013)

Alexandra Horowitz, *Inside of a Dog: What Dogs See, Smell and Know* (Simon & Schuster, 2012)

Maira Kalman, *Beloved Dog* (Penguin, 2015) – beautiful drawn memoir of the author's dog life

Mary Oliver, *Dog Songs* (Penguin, 2013) – wonderful dog poems

Some Useful Websites

Charities with online guides and information

Battersea Dogs & Cats Home: battersea.org.uk
Blue Cross: bluecross.org.uk
Dogs Trust: dogstrust.org.uk
RSPCA: rspca.org.uk

Food

For useful, comprehensive, detailed reviews of every brand and type of dog food sold in the UK see allaboutdogfood. co.uk – it's run by a canine nutritionist. Websites mentioned in the book are:

honeysrealdogfood.com
lilyskitchen.co.uk
naturesmenu.co.uk
nutriment.co

General dog goodness

For a UK-wide information directory, see thegooddogguide. com: UK-wide information directory. US-based dogster.com is like a giant dog magazine, with a useful video section, while

dogmilk.com has dog accessories and more. Websites mentioned in the book are:

chipmydog.org.uk
dogsandhorses.co.uk
friendlydogcollars.com
hindquarters.com
holisticvet.co.uk
housemydog.com
lovemydog.co.uk
mekuti.co.uk
protected-species.com
reddingo.com
themagnificenthound.co.uk

INDEX

accessories 221–9
adolescence 235–7, 238
ageing 255–6, 262–4
aggression 180–81
Aigle 225
Airedale terriers 50, 71
anal glands 120–21, 251
anthropomorphizing 230–33
Australian terriers 71
avocados 82

BARF diet *see* raw feeding
Barsotti, Charles 260
basenjis 45
basset hounds 48
baths 212–17
beaches 194–5
beagles 48
Bedlington terriers 70
beds
 dog beds 84, 227–8
 sharing with dogs 21–2,
 79–80
bee stings 204
Belgian shepherds 45–6

Best in Show 44
bichons frises 52, 70, 233
Billinghurst, Ian 121–2
biscuits 115, 128
 see also kibble
bitches 72–3, 235–6, 238
bloat 240
body language 168–9, 180–81
Bolognese 70
bones 121–2, 123, 124, 126,
 128, 229
Border collies 46
Border terriers 71
Bouviers des Flandres 46, 70
boxers 46
Bradshaw, John 148–52, 181
breeders 35–6, 42, 55–8
 puppy farming 36–8
 questions to ask 58–60
breeds 31–6, 43–4
 characteristics 169–70
 companion dogs 51–3
 cross-breeds 53–5
 gun dogs 50–51
 non/low-shedding 70–71

breeds (*cont.*)
 other things to think about
 65–72
 primitive dogs 45
 scent hounds 48
 sight hounds 47–8
 small dogs 61–5
 spitz-type dogs 46–7
 terriers 49–50
 working dogs 45–6
Brexit 194, 199
bristle brushes 208
Brodie 1–2, 7–8, 50,
 71, 75
 and baths 214
 being left alone 186
 and carrots 254
 chewing shoes 106–7
 and children 40,
 134–5
 and garden plants 83
 haircuts 211–12
 Japanese accent 233
 neutering 73
 as a puppy 100–101, 103
 and skateboards 140
 training 158
brushing 206–10
bull terriers 50
bulldogs 46, 49, 52

cables 81
Cairn terriers 71
candles 81
canine distemper 240
canine parvovirus 241
Canis lupus 109
carriage dogs 52–3
Cartwright-Loebl, Tamara 178,
 179
Cavalier King Charles spaniels
 52
Cesky terriers 71
charities 38–41, 272
chihuahuas 52, 64
children
 and dogs 3–4, 24–5, 40–41,
 64, 68, 96–7, 135–7
 getting the puppy home 96,
 98–9
 naming puppies 91
Chinese crested dogs 70
chocolate 82
Cockerpoos 53
collars 85, 88, 226
combs 208
'Come here' command 163–5
comfort blanket 76, 84
companion dogs 51–3
Conron, Wally 54–5
corgis 46

cost 23–4
Cotons de Tuléar 70
Cotswold Raw 126
crate-training 75–9, 181–2
cross-breeds 53–5

dachshunds 48, 210
Dalmatians 2, 52–3
Dandie Dinmont terriers 70
day care 191–2
death 259–66
diet *see* feeding
diseases 240–42
distemper 240
Dobermanns 2–3, 48
dog beds 84, 227–8
'Dog has Died, A' (Neruda)
 260–61
dog haters 133–6
dog hotels 195–6
dog-sitters 195
dog tags 229
dog trainers 155–6
dog treats 85–6, 104–6, 229
 dispensers 190
 in training 156–7, 168
dog walkers 23, 191
dogs 1–11
 accessories 221–9
 adolescence 235–7

ageing 255–6, 262–4
aggression 180–81
anal glands 120–21, 251
anthropomorphizing 230–33
badness 169–70
behaviour 9–10, 80, 131–8,
 147–53
body language 168–9, 180–81
breeders 55–61
and children 96–7, 135–7
choosing and buying 29–73
cost 23–4
day care 191–2
death 259–66
diseases and problems
 240–43, 250–51
dog or bitch 72–3
exercise 20, 22–3, 62–3, 65–6,
 192–3
fat 254–5
feeding 9, 82, 84–6, 104–5,
 109–28, 251–2
flatulence 251–2
grooming 201–3, 206–17,
 218–19
in heaven 259–61
and holidays 194–7
looks 30–31
mental stimulation 66–7
microchipping 42–3

dogs (*cont.*)
 middle age and beyond 239,
 245–56
 names 88–92
 nobility 246–7
 noisy 65–6
 pedigree dogs 43–55
 rehoming from charities
 38–41
 separation anxiety 173–80
 shedding 69–72
 should you get a dog 13–27
 small dogs 61–5
 smell 249–53
 and your social life 222–3
 spaying and neutering 73, 238
 teasing 97
 toys 184, 228–9
 training 5–7, 10, 21, 23–4,
 105–6, 143–7, 153–68
 travelling with 25
 who will look after 68–9
 see also breeds; puppies
Dogs Trust 39, 42
dogsandhorses.co.uk 226
'Down' command 161–2
Dunbar, Dr Ian 155

ears 202, 213
exercise 20, 22–3, 65–6, 192–3

small dogs 62–3
 two-sticks method 187–8
 see also walks
eyebrows 218–19
eyes 203, 213

feeding 9, 109–18, 272
 dog treats 85–6, 104–6, 229
 and flatulence 251–2
 food and water bowls 84–5
 raw feeding 118–28, 253
 unsuitable foods 82
fish 125
flatulence 251–2
Fogle, Ben 189
food bowls 84–5
fox poo 217–18
fox (wire) terriers 71
furniture 21, 79–80

garden plants 82–3
gastric torsion 240
gay dogs 64
Genius of Dogs, The (Hare and
 Woods) 173–4
German shepherds 46, 207
giant schnauzers 70
Give Your Dog a Bone (Billing-
 hurst) 121–2
Glen of Imaal terriers 70

grain 112–13, 116
grapes 82
grass seeds 242
Great Danes 46
green space 22–3
grey wolves 109, 111, 148–52
greyhounds 48
Groenendaels 46
grooming 201–3
 baths 212–17
 brushing 206–10
 eyebrows 218–19
 professional 210–12
grooming mitts 209
gun dogs 33, 50–51

Hare, Dr Brian 173–4
harnesses 227
Havanese 70
heaven 259–61
'Heel' command 165–7
hepatitis 240
herding dogs 31
Hindquarters 226, 227–8
holidays 194–7
 pet passports 198–9
holisticvet.co.uk 253
HomeSitters 195
Honey's Real Dog Food 125,
 127

hounds 47–8
House My Dog 195
house-training 78–9, 86–7,
 102–3
Hungarian Pulis 70
hunting dogs 47–8, 49, 169–70
huskies 31–3, 46

In Defence of Dogs (Bradshaw)
 148–52
insurance 23, 86, 198, 263
Irish terriers 50, 71
Irish water spaniels 70
Irish wolfhounds 48
Italian Spinoni 67

Jack Russells 50

Kennel Club 36–7, 55, 58, 70, 86
kennel cough 196, 240
kennels 196
Kerry Blue terriers 71
kibble 115, 128
King Charles spaniels 52
Komondors 70
Kong 184, 228

Labradoodles 54–5, 90
Labradors 51, 232–3
Lagotti Romagnoli 70

Lakeland terriers 71
Laverstoke Park 125
leads 85, 226–7
Lebowitz, Fran 221
Lhasa Apsos 71
Lily's Kitchen 127, 229
Lonsdale, Tom 123
lovemydog.co.uk 226
lungworm 240–41
lurchers 53
Lyme disease 241

malamutes 46
Malby, Penel 178–9
Maltese 52, 71
Maltipoos 53
mastiffs 46
matt-splitters 209–10
meat 111, 121–2, 123–5
 meat derivatives 114,
 117–18
mental stimulation 66–7
Mexican hairless dogs 71
microchipping 38, 42–3, 198
Millan, Cesar 152–3
miniature poodles 71, 233
miniature schnauzers 71
Modern Family 64
Most, Colonel Konrad 145
moulting 69–72

nails 202, 213–14
name tags 87–8
names 88–92
Nash, Ogden 265–6
Nature's Menu 125, 229
Neruda, Pablo 260–61
neutering 73, 238
nipping 99
noisy dogs 65–6
Norfolk terriers 50, 72
Norwich terriers 50, 72
Nutriment 125–6

Obama, Barack 55
obesity 254–5
'On a Good Dog' (Nash)
 265–6

Parson Russells 50
parva 241
patience 24
Patterdale terriers 50
paws 202
 grass seeds 242
pedigree dogs 34–5, 43–54
 breeders 55–60
 cost 23
 grooming 211
Pekingese 44, 52, 233
pet insurance 23, 86, 198, 263

pet passports 194, 198–9
pet shops 30, 37, 38
pinhead brushes 208
pointers 51
Pomeranians 47
poo sacks 85
poodles 52, 71, 233
 see also Cockerpoos; standard
 poodles
poos
 raw-fed dogs 119–21
 see also house-training
PortaShower 213
Portuguese water dogs 55, 71
praise 157, 167
primitive dogs 45
Protected Species 226
pugs 52
Puggles 53
punishment-based methods
 143–7, 152–4, 156
puppies
 buying a puppy 56–61
 collecting 92–3
 crate-training 75–9
 feeding 60
 first walk 141–3
 furniture and beds 79–80
 getting the puppy home
 95–107

house-training 17, 78–9,
 102–3
 naming 88–92
 nipping 99
 preparing for 75–93
 puppy-proofing your house
 80–83
 raw feeding 127
 should you get a dog 14–21
 siblings 60–61
 socializing 59, 139–41
 teething 16–17, 228
 things the puppy needs
 83–8
 weaning 59
 worming and vaccinations
 59
 see also breeders
puppy farming 36–8, 42

rabies 198
raisins 82
raw feeding 118, 121–8, 253
 poos 119–21
 puppies 127
Raw Meaty Bones: Promote Health
 (Lonsdale) 123
Rawlinson, Stan 267–8
Reconcile 178
rescue dogs 38–41, 272

rescue dogs (*cont.*)
 cost 23
 training 186–7
retrievers 31, 51, 207
rewards-based methods 146,
 154–5, 156–60
Rottweilers 46
rubber brushes 208
Russian Black terriers 71

St Bernards 46
scent hounds 48
schnauzers 46, 70, 71
Scottish terriers 72, 89
Sealyham terriers 71
separation anxiety 173–80
 what to do about it 181–94
setters 51
'Shackleton's Decision'
 (Shearin) 246–7
shampoo 214–15, 216, 217
Shar Peis 46
Shearin, Faith 246–7
shedding 69–72
shih-tzus 52, 71
shoes 106–7
sight hounds 47–8
'Sit' command 160–61
slicker brushes 207
small dogs 61–5, 66

smell 249–53
social life 222–3
Soft-Coated Wheaten terriers
 3, 7–8, 35, 50, 71, 158, 211
 see also Brodie
space 21–2, 67, 101–2
spaniels 51, 70
Spanish water dogs 71
spaying 73, 238
spitz-type dogs 46–7
Spratt, James 113–14
Staffordshire bull terriers 50,
 233
stair gates 80–81, 182
standard poodles 51, 71
 see also Labradoodles
'Stay' command 162–3
sticks
 safety 188–9
 two-sticks method 187–8
stripping combs 208

teasing 97
teeth 110, 124, 202, 237, 253
teething 16–17, 228
'10 Commandments from a
 Dog's Point of View, The'
 (Rawlinson) 267–8
tennis balls 228
terriers 49–50, 62, 63–4

shedding 70, 71–2
see also Soft-Coated Wheaten
 terriers
Tervuerens 46
themagnficenthound.co.uk 226
Thomas, Zoe 35–6
Tibetan terriers 71
ticks 205–6
time 13–14, 20
Titchmarsh, Alan 153
toilet-training 78–9, 86–7, 102–3
toy poodles 71
toys 184, 228–9
training 5–7, 10, 21, 23–4,
 105–6, 167–8
 basic commands 160–67
 'Come here' command 163–5
 crate-training 75–9
 dog treats 85–6
 'Down' command 161–2
 guidelines 156–7
 'Heel' command 165–7
 house-training 78–9, 86–7,
 102–3
 punishment-based methods
 143–7, 152–4, 156
 rewards-based methods 146,
 154–5, 156–60
 'Sit' command 160–61
 socializing puppies 139–41

'Stay' command 162–3
walking a puppy 141–3
travel 25
treats *see* dog treats
two-sticks method 187–8

undercoat rakes 209
Up 51

vaccinations 59, 196, 198, 240,
 241
vets 23, 86
 microchipping 42
 and pet food 115–16
vizslas 33, 51

walks
 clothes for 225–6
 dog walkers 191
 puppies 141–3
 and social life 222–3
 see also exercise
wasp stings 204
water bowls 84–5
webcams 177, 186
Weil's disease 241–2
Weimaraners 51
Wheatens *see* Soft-Coated
 Wheaten terriers
whippets 48

White, E. B. 269–71
wide-toothed combs 208
wolves 9–10, 45, 109, 111,
 148–52, 173
Woodhouse, Barbara 152

Woods, Vanessa 173–4
working dogs 31, 45–6
worming 59, 198, 240–41

Yorkshire terriers 50, 71, 233

ACKNOWLEDGEMENTS

Giant and especial thanks to the brilliant Sally Muir for her utterly wonderful paintings and illustrations. You can see (and purchase, and commission) more of them at sallymuir.co.uk.

Thanks as ever to my beloved publisher, Juliet Annan, and to my agent Georgia Garrett (also beloved).

Thanks to all the knowledgeable dog people I've met in the course of dog ownership, especially to Louise Glazebrook (if you're in London and need one-on-one dog help/training, she's your gal – see thedarlingdogcompany.co.uk) and to Ruth Naylor.

Thanks to Zoe Thomas, a lovely breeder of Soft-Coated Wheaten terriers. Thanks to God for inventing Soft-Coated Wheaten terriers.

Thanks to Sali Hughes, Hadley Freeman and Bella Mackie for the dog chat, on and off Twitter. Thanks to Zadie Smith for her heartfelt, quietly persistent defence of small dogs over the years. Thanks to Sophia Langmead and Emily Matthews. And thanks to Eric Joyce, who is a bit like a kind, flower-sniffing Rottweiler, and Top Dog of my heart.